MINIMAL POLITICS

ISSUES

IN

CULTURAL

THEORY

1

FINE ARTS GALLERY
UNIVERSITY OF MARYLAND,
BALTIMORE COUNTY

MAURICE BERGER

MINIMAL POLITICS

PERFORMATIVITY

AND

MINIMALISM

IN

RECENT

AMERICAN

ART

PARTICIPATING ARTISTS

HANS HAACKE

MARY KELLY

ROBERT MORRIS

ADRIAN PIPER

YVONNE RAINER

DISTRIBUTED BY

DISTRIBUTED ART

PUBLISHERS

NEW YORK

1997

This volume, the first title in the series
Issues in Cultural Theory, is published in
conjunction with *Minimal Politics*, an
exhibition organized by the Fine Arts Gallery,
University of Maryland, Baltimore County.

September 25, 1997, through January 17, 1998

Exhibition itinerary in formation.

*This exhibition and publication have been
funded in part by the Andy Warhol Foundation for
the Visual Arts, the Elizabeth Firestone Graham
Foundation, and the Maryland State Arts Council.*

Copyright © 1997
Published by the Fine Arts Gallery
University of Maryland, Baltimore County
Baltimore, Maryland 21250

Published 1997
Printed in the United States of America

Library of Congress Catalog Card number
97-61646

ISBN 1-890761-00-1

CONTENTS

PREFACE

Maurice Berger once again brings new messages to my mind, with his continuing exploration of important art work, in his careful selection of that work, and in his ability to center the work with vitality, ideas, and analysis. The work gains power in this context and continues to allow me to understand new meanings and messages.

This volume, published in conjunction with *Minimal Politics*, serves as more than just an exhibition catalogue. It is a full-length book that explores through multiple literary and discursive forms, the complex relationship between form, theatricality, and ideology in the work of five brilliant and highly influential artists—Hans Haacke, Mary Kelly, Robert Morris, Adrian Piper, and Yvonne Rainer. *Minimal Politics* not only marks another step in the Fine Arts Gallery's commitment to progressive exhibitions, but inaugurates a new annual book series—*Issues in Cultural Theory*—the first of its kind for the University. Forthcoming editions will explore such issues as the modernist design and theory of the Swiss designer Bruno Monguzzi and the issues of "blackness" and "whiteness" in the work and theory of the artist and philosopher Adrian Piper. The series, which will be distributed internationally by Distributed Art Publishers (D.A.P.), will be edited by Maurice Berger, newly named Adjunct Curator of the Fine Arts Gallery.

DAVID YAGER

EXECUTIVE DIRECTOR
FINE ARTS GALLERY

ACKNOWLEDGMENTS

I should like to thank a number of people for their generous advice, assistance, and insights. The gallery staff was, as always, outstanding in its attention to every detail of the exhibition and book. Symmes Gardner, Director of Programs, met the demands of this project with his customary grace, intelligence, talent, and patience. Monika Graves, Projects Coordinator, was helpful at every turn, offering much needed support and advice with her usual care and rigor. Antonia Gardner was an editor in the finest tradition: although she paid careful attention to every detail, both grammatical and stylistic, in the text, she never lost sight of the argument itself, making it stronger with each touch of her pen. Designer Franc Nunoo-Quarcoo's perceptive interpretation of the intellectual and aesthetic issues of this exhibition resulted in a design that was at once beautiful, resonant, and knowing. David Yager, Executive Director, once again proved the broadness and depth of his vision: rather than retreating from the difficult and complex subject matter of Minimal Politics, he encouraged intellectual rigor rather than compromise, progressive curatorial practices rather than safe ones.

I should like to thank my friends and colleagues Mason Klein, Therese Lichtenstein, and Kathy O'Dell for the much needed advice they offered at all stages of the planning and execution of this project. Marvin Heiferman was, as usual, a pillar of love and support; his ideas and editorial advice represent a significant contribution to this project. In allowing me unprecedented access to the archives of her late husband, the photographer Peter Moore, Barbara Moore went far in making this exhibition possible. She graciously and generously annotated and prepared each extraordinary photograph for inclusion in this exhibition and book. I am grateful for her patience, knowledge, friendship, and magnanimity.

I would like to especially thank the following foundations, organizations, and individuals for the generous funding they provided for *Minimal Politics*. This project would have suffered greatly without their generosity, goodwill, and commitment to progressive and revisionist curatorial practice: the Elizabeth Firestone Graham Foundation, the Andy Warhol Foundation for the Visual Arts, and the Maryland State Arts Council.

For their assistance in securing loans of artwork for this exhibition, I would like to thank the following individuals and organizations. In New York, John Hatfield of the New Museum of Contemporary Art, Jon Ippolito of the Guggenheim Soho, Elyse Goldberg of John Weber Gallery, and Sonnabend Gallery. In Los Angeles, Ray Barrie was instrumental in securing Mary Kelly's early work for the exhibition. All have been extremely generous with their time and attention to this project.

Finally, I would like to extend my deepest gratitude to the artists in this exhibition–Hans Haacke, Mary Kelly, Robert Morris, Adrian Piper, and Yvonne Rainer. I am proud to call each a friend. Each has influenced my thinking, sometimes in areas far removed from the study of art and art history. Each has been quick to provide advice and support. Each has bravely pursued a complex, uncompromising, and often controversial artistic vision. It has been a profound pleasure to work with them.

MAURICE BERGER

SENIOR FELLOW
THE VERA LIST CENTER
FOR ART AND POLITICS
NEW SCHOOL FOR
SOCIAL RESEARCH

ADJUNCT CURATOR
FINE ARTS GALLERY
UNIVERSITY OF MARYLAND,
BALTIMORE COUNTY

MAURICE BERGER

MINIMAL POLITICS

———

PERFORMATIVITY
AND
MINIMALISM
IN
RECENT
AMERICAN
ART

In a stark, brightly lit gallery stand two monumental cubes, one painted white, the other black. At first glance, the eight-foot boxes appear to be classic examples of the reductivist, geometric mono-liths of the mid-1960s known as minimalist sculpture. As the viewer nears, however, muffled sounds can be heard emanating from each of the cubes. The viewer enters their dark and claus-trophobic interiors through doorlike apertures. Once inside either of the specialized "viewing units," the spectator sits in a comfortable armchair. In the white box an image-screen plays a loop of the infamous videotape that documented motorist Rodney King being beaten by Los Angeles police in March 1991. The room's smoke-gray walls are made even more claustrophobic and alarming by the recorded sound of fire. In the black box the view-er faces a backlit photograph of King, his features distorted by the contusions sustained in the attack. When the light-box suddenly switches off, an interrogation lamp shines into the spectator's eyes, and the light-box's darkened, reflective surface mirrors back the sitter's face. In the background a recording of King's now famous plea for peace during the riots repeats, "Can't we all just get along? . . . Can't we all just get along? . . . Can't we all just get along?"

Black Box/White Box (1992), an installation by the artist-philosopher Adrian Piper, in its charged relationship to the spec-tator, does something that has ostensibly never before been done: it merges the minimalist stylistic and conceptual agenda with the politics of race and racism. The seemingly incongruous conver-gence of minimalist forms and political content reveals a kind of art historical conundrum. On the face of it, minimalism's inherent

formalism and hermeticism, its use of elemental geometric forms and gestures, and its rejection of narrative content would appear to mitigate against social or political meaning. Art critics in the mid-1960s often theorized minimalism as the endgame of formalist abstraction in dance, painting, and sculpture, the culmination of modernism's art for art's sake ethos.[1] Even its practitioners sometimes supported this view. Yvonne Rainer, one of the groundbreaking and influential minimalist choreographers of the 1960s, adamantly denied, at the time, any relationship between her dances and the troubled world outside. She maintained that ideological issues were neither explored nor reflected in her pared-down works and that the "tenor of current political and social conditions" had no "bearing on [their] execution."[2]

Despite Rainer's apolitical stance, her artistic evolution from formalist to activist over the next decade was paradigmatic of many artists and dancers of the period. In retrospect, even her most resolutely "minimal" strategies–the radical rejection of the illusions of modern dance and ballet, the reliance on everyday gestures and clothing, and the democratic (i.e., nonhierarchical) deployment of dancers–now seem ideological. Indeed, by the end of the 1960s Rainer's rigid formalism had evolved into such dance pieces as *War* (1970)–an antiwar meditation chronicling American atrocities in Vietnam that juxtaposed simple, reductivist movements and street clothes with a spoken narrative.[3] From the mid-1960s to the early 1970s, many other cultural figures–including Hans Haacke, Mary Kelly, Robert Morris, and Adrian Piper–followed the same trajectory, to one extent or another trading in the

cool, formalist aesthetics of minimalism for the harsher realities of politics and social activism.

Their aesthetic journey raises significant and complex questions about the nature of art and politics: What aspects of these artists' minimalism–the more direct address to the spectator, the employment of reductivist forms and gestures, the rethinking of pedestals, classical staging, and other distancing devices, the use of factory-fabricated forms, industrial materials, and everyday movements and street clothes–would engender or support political content? What aspects of minimalism had to be rejected in order to transcend its seemingly formalist sensibility? And what aspects of the political issues later explored by these artists, issues such as gender and sexual roles, class, cultural patronage, the institutional hierarchies of the art world, and race and racism, were already inherent in the minimalist ethos?

There are only a few critical/theoretical attempts to deal with the relationship between ideology and form in recent contemporary art. My own book, *Labyrinths: Robert Morris, Minimalism, and the 1960s*–while it deals with issues of minimal art and its relationship to the New Left and the writings of Herbert Marcuse–does not touch upon issues of race, sexuality, and gender, subjects that were of less interest to Morris. More recently, the Museum of Modern Art's *Sense and Sensibility: Women Artists and Minimalism in the 1990s*, organized by Lynn Zelevansky, while intriguing, does not deal in depth with earlier art–in effect relegating its discussion to a group of younger women artists. The purpose of this book is to construct a broader theory for under-

standing and evaluating the ideology of the minimalist/conceptu-
alist agenda–an enterprise that counteracts the tendency of art
historians to elide the social and ideological issues and influences
that have underwritten avant-garde art over the past 30 years.[4]

The confluence of minimalism and ideology has been nei-
ther consistent nor uniform in the visual and performing arts. By
the early 1970s, Rainer had given up minimalist choreography
altogether, opting instead to write, direct, and perform in some of
the most intellectually challenging and socially conscious avant-
garde films of the past quarter century. Morris, as well, in works
such as his *Cenotaph* series (1980), an installation replete with
doomsday narratives etched onto faux-marble slabs capped with
skulls, appears to contradict the tone and sensibility of his most
reductive and severe works of the mid-1960s (*Untitled [L-Beams]*,
1965). Hans Haacke and Mary Kelly, on the other hand, never
produced the kind of strictly minimal art characteristic of the
mid-1960s; instead, they adapted aspects of the minimalist aes-
thetic throughout all phases of their oeuvre. In *Alcoa: We can't wait
for tomorrow* (1979), Haacke renders provocative a cool, artful alu-
minum plinth with an inscription by then-president of Alcoa
William B. Renner. His statement that "Business could hold art
exhibitions to tell its own story" was made at the time of a widely
publicized Internal Revenue Service investigation revealing the
company's questionable political contributions. In *Interim, Part iv:
"Potestas"* (1989), Kelly arranges sleek steel plates on the wall to
form a bar graph that measures relationships between money,
property, and position, underscoring the extent to which social

and sexual divisions of power are themselves embedded in our everyday lives.

Despite such interconnections, art historians and critics most often have reduced the minimalist ethos to questions of style and form, ignoring minimalism's social or ideological motivations, even though the very aesthetic from which all of this work emerges was itself often underwritten by social and ideological issues. The art historical indifference to minimalism's social basis suggest a serious methodological problem: rather than closely examining the social and cultural convergences of the period, a time of great political upheaval, such "histories" of the '60s have retreated to narrow historicized readings. These studies would overlook that artists such as Haacke, Kelly, Morris, Piper, and Rainer were involved in political activism, including the antiwar, student, feminist, and civil rights movements. Recent, socially aware attempts at critical and art historical revisionism, however, have discovered powerful ideological forces and influences for this work. Thus the formalist or phenomenological theories usually employed to understand minimalism are opening up to admit the important contemporary names, movements, and ideas that have been left out of earlier art historical narratives. The writings of such philosophers and critics as Maurice Merleau-Ponty, Charles Sanders Peirce, Annette Michelson, Rosalind Krauss, Clement Greenberg, Michael Fried, Lawrence Alloway, and Barbara Rose are being supplemented by such contemporaneous influences as the antiwar and Free Speech movements, the Artworkers' Coalition, feminism, Michel Foucault, Guerrilla Art Action Group, R. D. Laing, Lucy Lippard, Herbert Marcuse, Marxism,

Neo-Marxism and the critique of commodity fetishism, the New Left, and Women Artists in Revolution.5

These revisionist readings have allowed the art historian to discern ideological motivations in aspects of the minimalist aesthetic most often considered purely stylistic. Rather than just formal, neutral gray plinths, Morris's minimalist sculptures of the mid-1960s were committed to reshaping the traditional relationship between object and viewer. Morris was committed to the idea that the art object could transgress the repressiveness of rarefied and precious art objects–a notion directly rooted in his political and philosophical education in the 1950s and '60s.

Morris believed that such a transgression was aided, for example, by the elimination of pedestals and the creation of sculptural objects that yielded to rather than transcended gravity. Morris's elemental cubes, plinths, and planes of the mid-1960s, for example, were not just a rejection of the precious, transcendent art object; they were also a transgression of the repressive, distancing tone of modernist sculpture. For Morris, Constantine Brancusi's soaring monoliths were not a flight into freedom, but rather a retreat into a compulsive, precious aesthetic that intimidated rather than welcomed the viewer. Morris argued in his 1964 Hunter College master's thesis on the artist that it was only Brancusi's elaborately designed and carved pedestals and sculptural bases that were important, because they were less oppressive and transcendent. "All of the work's sexual energy, all the implications of violence," wrote Morris, "were below a neutral axis, repressed in the base. What lay above these pedestals was absurd–obsessive, repressive, puritanical." 6

One significant influence on Morris's art and ideas was the writings of Herbert Marcuse. As a philosophy major at Reed College in the mid-1950s and later as an artist in New York in the 1960s, Morris actively read and debated the work of the philosopher and activist.[7] The writings of Marcuse, particularly *Eros and Civilization* (1955), served as an influential manifesto of libidinal and political freedom in the 1960s. Morris was most influenced by Marcuse's idea of the desublimative power of the art object, its ability to liberate the body and sexuality from the oppressive, work-oriented economy of industrial and corporate life.[8]

The greatest Marcusean, and hence ideological, dimension of Morris's minimalist sculptures of the mid-1960s is the immediate and liberating way they relate to the spectator. In effect, minimalist sculpture radically altered the way art objects engaged viewers, granting them an unprecedented degree of interaction and control in the experience of art. Morris, for example, provocatively placed or scattered at the viewer's feet the cubes, slabs, plinths, soil, steam that made up his minimalist sculptural vocabulary. Instead of precious art objects, self-contained forms redolent with associations and historical allusions, these dispersed and relatively neutral forms needed to *interact* with a spectator in order to be fully operative and meaningful.

Minimalism's disruption of the traditional relationship between a fixed, static object and a fixated and static viewer was directly tied to the exigencies of contemporary performance and dance, thus the floor-bound arrangements of copper, lead, or steel tiles which the viewer walked directly on or across (Carl Andre,

144 Pieces of Lead, 1969), labyrinths through which the viewer navigated (Morris, *Passageway*, 1961), rectilinear cement slabs that were placed on a snowy slope in King City, Canada, that blocked and exposed different vistas as the viewer moved over and around them (Richard Serra, *Shift*, 1970-72), a mirrored doorway that reflected the viewer's movements as he walked through it (Morris, *Untitled*, 1961). The unadorned, everyday movements and unidealized body that characterized the radical, reductive choreography of the mid-1960s were advanced by such "minimalist" choreographers as Yvonne Rainer, Simone Forti, Deborah Hay, Lucinda Childs, Trisha Brown, Steve Paxton, and even Morris himself and closely paralleled the use of industrial materials, temporal interaction, and simplified forms in minimalist sculpture.

In a 1965 essay that argued for a "one-to-one relationship between aspects of so-called minimalist sculpture and recent dance," Rainer charted specific formal or stylistic convergences between the two sensibilities: the "factory fabrication" favored by minimalist sculptors, for example, was comparable to the choreographer's interest in "energy equality" and "found" (i.e., everyday or ordinary) movement; sculptural "literalness" was paralleled by the choreographic reliance on "task[s] or tasklike activity"; "simplicity" of form paralleled the dancer's use of "singular action, event, or tone"; and both minimalist object and dance relied on "human scale."9

Rainer was both identifying and advocating a new dance that was as literal and non-narrative as the neutral plinths, cubes, and beams that were the basic forms of minimal sculpture. "The

demands made on the body's (actual) energy resources," observed Rainer, "*appear* to be commensurate with the task–be it getting up from the floor, raising an arm, tilting the pelvis, etc.–much as one would get out of a chair, reach for a high shelf, or walk down stairs when one was not in a hurry."[10] The pedestrian character of the new dance, as Rainer theorized it, was reflected in the work's disavowal of traditional dance hierarchies: the notion of the principal dancer was eschewed; the narcissism attached to the beautiful dancer's body was suppressed (more often than not, ordinary clothes were worn); and romantic, balletic gestures and flourishes were eliminated. Conversely, the transgressions of the new dance were brilliantly transmuted into the temporal, even theatrical sensibility of the new sculpture. Rather than incidental or even irrelevant, the performance pieces, dances, and films of such minimalist sculptors as Robert Morris (politicized dance pieces, e.g., *War*, 1962, *Site*, 1963, *Waterman Switch*, 1965) and Richard Serra (process-oriented films, e.g., *One Hand Catching Lead*, 1969) emerged directly out of their aesthetic and philosophical vision.[11]

One of the most cogent arguments for the "theatrical" nature of minimalist sculpture appears, ironically, in the writings on one of the movement's most ardent detractors, the formalist art critic Michael Fried. In his seminal essay "Art and Objecthood" (1967), Fried condemned what he saw as the "theatricality" of the new sculpture, claiming that it was "at war with . . . art."[12] Fried emphasized the pictorial and illusionist possibilities of sculpture, arguing that sculpture's survival (like the survival of painting) depended on its ability to distinguish itself as art. For such mod-

ernist painting as Cubism, Constructivism, and Abstract Expressionism, work that was often utopian and spiritual in its associations, the problem was to transcend the literal shape of its support. For Fried, painting could be declared art *a priori*, because the field of the canvas was understood as separate from the real world. As such, the literal condition of the canvas as *object* had to be overcome in order for it to be truly transcendent. His formalist reasoning extended to sculpture, where the object sought to transcend its base material state. Because "minimal" or "literalist" art relied on actual, anti-illusionist shape, Fried argued that it existed to "discover and project objecthood as such."[13] In other words, literal presence had become the principal goal of many minimalist objects, thus placing in question their ability to transcend the real world and rise to the level of art.

Despite his moralizing conclusions, Fried's observations were remarkably perceptive. Morris, for example, by disengaging sculpture from the task of representing other objects in the world, expressly wanted to avoid psychological or narrative references in order to create an immediate sculptural experience. Additionally, Morris (as well as a number of his contemporaries) sought to prolong and intensify this experience by confounding or confusing the spectator's perception of the objects in question. He would distort the shape of elemental forms (such as the slanting of one side of each of four cubes), for example, in order to upset the expected gestalt of that shape. The viewer would then be compelled to move around and even through a piece in order to understand what he was seeing. As Fried notes, in contrast to the

traditional art object, where "what is to be had from the work is located strictly within [it]," to experience Morris's sculpture is to engage an "object *in a situation*–one that, virtually by definition, *includes the beholder.*"[14]

Fried considered this complex interplay between viewer and object "theatrical"–and, consequently, inappropriate for sculpture. For him, the altered status of the spectator in the presence of such "literal" sculpture amounted to "nothing more than a plea for a new genre of theater; and theater is now the negation of art."[15] In a sense, Fried was correct, for Morris's disorientation of the spectator–through the use of altered gestalts, for example–was meant as a deliberate negation of traditional sculpture. In addition, the viewer was distanced by the objects themselves, objects inserted directly into the flow of their ambient space without recourse to pedestals. "The beholder knows himself to stand in an intermediate, open-ended–and unexacting–relation *as subject* to the impassive object on the wall or floor," Fried wrote. "In fact, being distanced by such objects is not, I suggest, entirely unlike being distanced or crowded by the silent presence of another person; the experience of coming upon literalist objects unexpectedly . . . can be strongly, if momentarily disquieting in just this way."[16] Because he opposed the idea of theatricality in art, Fried never felt compelled to ask a rather obvious question: Why was "theatrical" space and time so important to avant-garde artists of the 1960s?

The most engaging answer to this question thus far has come from those critics who have argued for a phenomenological

reading of minimalism.[17] The phenomenological ethos, already current in the writings of a number of minimalist sculptors of the mid-1960s and rooted in the tracts of such philosophers as Maurice Merleau-Ponty and Charles Sanders Peirce, rejected an *a priori* and preordained understanding of things in the world. Rather than relying on logic and intellectual constructions for understanding what we see and do, phenomenology called for an understanding of the self through a direct, experiential interaction with the world. In a 1969 essay on Morris, for example, Annette Michelson argued that the formalist critical vocabulary, which centered on such transcendent and metaphysical ideals as "saying," "expressing," "embodying," "incarnating," and "symbolizing," made it impossible to understand the temporal, experiential, and literalist conditions of minimalism, conditions that disrupted the logic-driven world view of modernism.[18] She argued, for example, that Morris was committed to the idea of the sculptural experience as public rather than intimate.

Michelson pointed to Peirce's idea of "epistemological firstness" as a model for Morris's (and other minimalist sculptors') phenomenology. Peirce proposed a quality of immediate, concrete, simple apprehension that served, according to Michelson, as "the first focus of an investigation of the most general conditions of experience, of knowing and perceiving."[19] Peirce advocated the condition of absolute presentness unencumbered by the restraints of psychological association or memory:

> *Imagine . . . a consciousness in which there is no comparison,*
> *no relation, no recognized multiplicity . . . no change, no*

imagination of any modification of what is positively there,
no reflection–nothing but a simple positive character. Such a
consciousness might just be an odor, say a smell of attar; or it
might be one infinite dead ache; it might be the hearing of a
piercing internal whistle. In short, any simple and positive
quality would be something which our description fits that
it is such as it is quite regardless of anything else.[20]

"Firstness," then, is noncognitive, an experience fully dependent on literal feelings and perceptions and hence wholly incompatible with the collapsed, harmonic, and idealized time of modernist painting and sculpture.

Ultimately, Morris, in a manner wholly commensurate with Peirce's ideal of phenomenological firstness, explored the way the spectator, as the *subject* of the sculptural experience, apprehended visual and tactile information in time. The viewer's understanding of place and time was wholly dependent on experiencing other beings and other things in the world and on the act of establishing connections to them. In other words, Morris's aesthetic philosophy, like that of many of his contemporaries, disavowed the illusion of the self as a contained independent whole by acknowledging that we can only "know" the world by connecting with other selves, other minds, and other things.[21]

Neither Fried's nor Michelson's understanding of the theatrical or phenomenological roots of minimalism, however, considered the ideological reasons for redirecting the sculptural experience away from complex sculptural objects and toward the subjecthood of the viewer.[22] To understand the essentially *politi-*

cal nature of such activity–whether in watching dancer Lucinda
Childs repetitively walking toward and away from the spectator,
seeing oneself reflected in the mirrored surfaces of Morris's
Untitled [Four Mirrored Cubes] (1965), or walking across Carl
Andre's arrangements of lead floor tiles–requires a trenchant
methodological shift from the concept of the theatrical, a notion
rooted in the critical methodologies of the 1950s, to a theoretical
concept that has only recently come into play: the performative.[23]

Over the past few decades, the disciplines of theater and
performance studies have branched out to embrace and analyze a
broad range of performance practices, from cultural festivals and
political demonstrations to cooking and health care. Instead of the
removed, preordained, and staged articulations of the theater,
sensibilities alien to minimalism, the "performative" encompasses
the broader range of human enactments and interactions–the per-
formances of our everyday lives, the things we do to survive, to
communicate, to thrive, to manipulate, to procreate, to love; it
charts the direct and seemingly ordinary interaction between the
individual and society and culture at large; it enacts or is shaped
by the dynamics of power that determine our everyday actions; it
takes a myriad of forms, from the act of getting dressed in the
morning to the interpersonal interactions we have with our fami-
lies, colleagues, and friends; it is central to the formation of our
individual identities. Performativity, in short, is the infiltration of
performance into the social and cultural sphere, an infiltration
that is never less than meaningful, never less than ideological.
Over the past three decades, the development of performative

strategies in the creation and display of art has constituted a revolutionary alternative to the traditional modalities of performance, art, and theater. As Andrew Parker and Eve Kosofsky Sedgwick write,

> *Arguably, it's the aptitude of the . . . performative for mobilizing and epitomizing such transformative effects on interlocutory space that makes it almost irresistible . . . to associate it with theatrical performance. And to associate it, by the same token, with political activism, or with ritual. But that association also seems to throw off center a conventional definition of theater. In particular, it challenges any definition of theater according to which the relation between theatrical speakers and the words they speak would have to be seen as fixed in advance, as definitionally consistent. . . . If a specialized, postmodernist performative analysis . . . can demonstrate any one thing, surely it is how contingent and radically* heterogeneous, *as well as how* contestable, *must be the relationship between any subject and any utterance.*[24]

The performative nature of minimalist art and dance is in its freedom from the conceits and historical allusions of traditional art objects, its foregrounding of the viewer as an equal player in the aesthetic experience, and its creation of phenomenological games in which the self is explored through unscripted, temporal interaction with external forces and objects. This performativity has made it remarkably well suited to examining the social and

cultural contingencies of representation and identity and to contesting the repressive ways in which meaning, and even selfhood itself, are dictated by *a priori* social constructions. Not surprisingly, then, minimalist performativity, embodied by a temporal, experiential, and spectator-driven style directly influenced by the antiestablishment, pro-individual, and liberatory ideologies of its age, has meshed with the interests of those artists who have wished to explore or contest the social relationships of identity, power, and selfhood. This performative aesthetic has come to influence the formal, stylistic, and philosophical sensibilities of much political art of the past thirty years in multiple and complex ways.

Hans Haacke, for example, "recycled" minimalism, capitalizing on its ability to relate in size, temporality, and scale to the viewer's body. While "sympathetic to so-called minimal art," Haacke wanted to work beyond its "determined aloofness," a sensibility that he believed resulted in a cold, geometric formalism that tended to distance the viewer from political issues and concerns.[25] Thus Haacke further politicized the performative aspects of minimalism in works such as *MOMA-Poll* (1970), in which visitors to the *Information* exhibition at the Museum of Modern Art deposited ballots into Plexiglas boxes indicating whether they could support New York Governor Nelson Rockefeller's reelection bid given his refusal to denounce President Nixon's hawkish Indochina policy. The performative aspects of Haacke's work extended to installations as disparate as viewer surveys that charted the economic and political demographics of the art world (*John Weber Gallery Visitors' Profile 1,*

1972) to a series of identical aluminum windows, hung from the ceiling throughout the gallery space, that served as frames for images and narratives that explored the relationship between corporate investment in South Africa and apartheid (*Voici Alcan*, 1983).[26]

Adrian Piper, who continues to refer to herself as a minimalist, has also melded politics with the industrial materials, pure forms, and the performativity of minimalism.[27] As early as the late 1960s, Piper, who was a student of the minimal artist Sol LeWitt, engaged in a series of phenomenological exercises dealing with perception and sense of place. In the *Hypothesis Series* (1968-70), for example, she photographed and charted her own passage through various spatial situations.[28] Her early forays into minimalist performativity–her "Garden of Eden" period as she has called it–were to a great extent removed from the problems of racism and sexism that would later form the conceptual basis of her work. The shift in her aesthetic concerns occurred with the political upheavals of the period–the U.S. invasion of Cambodia, the student revolts, and the killing of student protesters at Kent State and Jackson State universities.[29]

From the early '70s onward, Piper strove to reconcile the phenomenological, viewer-oriented mind and body games of minimalism with the reality of her own oppression as an African-American woman and the painful repercussions of racism and sexism in the United States. "It would make sense to think of minimal art decision-making," writes Piper, "as a kind of aesthetic strategy for drawing attention to the concrete, specific, unique

qualities of individuals, and that is what my work does."[30] Thus, Piper takes advantage of the viewer-oriented devices of minimalist performativity in works like *Black Cube/White Cube* or *Vote/Emote* (1991), in which viewers enter stark black "voting booths" and anonymously record their feelings about the black faces that appear in front of them.

Nowhere was the confluence of minimalism, the performative, and ideology more dramatically sustained than in the visual culture of theoretical feminism. This relationship existed not only in the so-called post-minimalist practices of artists such as Eva Hesse and Lygia Clark, where social and biological concerns were encoded into biomorphic, albeit minimal, form, but in the practices and legacy of the more hard-edged minimalism of the 1960s. According to Rainer, even her most austere work for the Judson Dance Theater was essentially gender-specific:

> *I imitated women in the subway. I had screaming fits. I was sexy. I was always being someone else on stage. . . . What I was doing was taking things from life and transposing them into dramatic form.*[31]

While liberal feminism was closely allied with various types of political action performance in the 1960s, theoretical feminists such as Rainer and Kelly searched for a radical art that could challenge the viewer without disempowering or obscuring their own authorship.[32] Minimalism tended to discourage the artist's personal voice; political action performance, while centered on personal or autobiographical narratives, lacked the theoretical and physical integrity necessary to empower the artist in an art world

dominated by the exigencies of masculine authority and the object. Theoretical feminists often desired to have it both ways: "Although [Michael] Fried referred to the minimal object as having 'stage presence,'" observed Kelly, "in effect it remained no more than a prop without the intervention of the actor/artist and his script. Ultimately, it became necessary and expedient for the artist to stage himself."[33] Kelly's observation suggests the extent to which minimalist performativity could be adapted to the feminist agenda—a performativity that searched not for truth (woman as "muse") or absolutes (the "essence" of woman) but for the female body in relation to social forces, identity, feeling, power, and temporal experience.[34]

Kelly's *Post-Partum Document* (1973-79), one of this century's most significant and influential artistic statements on identity, represents the ultimate merging of feminism and minimalist performativity—a conceptual and aesthetic marriage exemplified by the work's repetitive form, temporal, almost cinematic format, use of ordinary materials and representation of mundane rituals, and its phenomenological, day-by-day recording of the relationship between Kelly and her newborn son. As Kelly observes,

> *The Document's procedural emphasis was often seen as performative. . . . The art object's "dematerialization" was effected on the one hand as a systematic displacement of its spatial integrity, and on the other as a substitution of the body as its temporal metaphor. The ephemeral yet emotive presence of the work "performed" subverted phenomenological [minimalist] reduction as well as philosophical ordering by introducing the unpredictable dimension of spectatorial*

transference.[35]

By relying on such devices as repetition, serialization, temporal and interactive engagement, and the use of proplike objects such as soiled diapers and children's clothing, the *Document* strikes an unprecedented balance between objecthood, minimalist performativity, and political performance; the viewer's eye, body, and mind rather than fixated on a static visual narrative are engaged in a complex phenomenology. Through Kelly's series of images and forms, the infant's process of socialization unfolds serially, though fitfully, as a kind of cinematic parallel to the way selfhood itself is formed. Thus developmental steps such as weaning from the breast and learning to speak form the Oedipal drama as it unfolds in Kelly's repetitive continuum of objects, words, and photographs and is viscerally *experienced* rather than statically received. Neither ephemeral theater piece nor inert photographic documentary, the work never loses its potential to engage the viewer and activate the space of exhibition.[36]

The terms of this engagement have created a broad array of aesthetic strategies that link the ethos of minimalism–stylistic, performative, and ideological–with a range of socio-cultural issues and agendas. This ideologically oriented brand of minimalism–whether its subject be the tragedy of totalitarian and fascistic regimes (Morris, *Disappearing Places*, 1990) or the politics of breast cancer and the interpersonal realities of lesbian relationships (Rainer, *MURDER and murder*, 1996)–understands, perhaps more effectively than most so-called political art, that form matters and that the relationship between viewer and art object, when carefully constructed and considered, can empower the social

content of art. While such work maintains an almost stubborn relationship to the institutions of art and art making–after all, nearly all of these cultural objects are intended for exhibition in art galleries, museums, or film festivals and theaters–it also believes in the potential of the aesthetic object to effect change, if even in the minds' eyes of the art world's elite patrons or in the context of a cultural "trickle-down effect" in which high-minded, rigorous ideas slowly make their way into the broader cultural consciousness. While Yvonne Rainer, for example, never wanted to be "restricted to Minimalism's anti-metaphorical strategy," she nevertheless employed its complex and theoretically rigorous formal devices–the cinematic use of repetition, the obsession with abstract formal relationships, the ironic depiction of characters bursting out (and perhaps transcending the limitations) of a minimalist-style box at the end of her first film, *Lives of Performers* (1972)–to strengthen the visual impact of her cinematic imagery. [37] In effect, such strategies represent a moving and radical commitment to the avant-garde and to progressive cultural theory, to a space of cultural production and engagement long eclipsed by the more accessible (and potentially more effective) strategies of the mass media.

There is a dramatic moment about halfway through Rainer's film *The Man Who Envied Women* (1985)–a Marxist-psychoanalytical meditation on men, women, and power–that most poignantly sums up the complex interconnection between performativity and minimalism and minimalism and ideology. The film's sexist and conflicted male protagonist, Jack Deller, a university professor, is speaking during a session with his off-camera psychotherapist. He is contemplating whether a "man can genuinely be in love with more than one woman," whether monogamy itself

is natural and immutable. More than anything, Deller is inquiring into his own struggle as a man with intimacy: "I suppose a man who was married for almost 21 years to a woman he adored becomes in a sense a lover of all women," he concludes, "and is forever seeking, even though he doesn't know it . . . something he has lost." Cinematically, the scene would be rather mundane, even ordinary if not for the fact that Deller sits in front of a large screen on which is projected a clip from a slow-motion section of the Trisha Brown/Babette Mangold dance film *Watermotor*–a hallmark of minimalist choreography. As Brown's body slowly glides across the screen, her ordinary street clothes, gestures, and movements almost matching the deadpan tone of Deller's psychological and political monologue, we realize that the juxtaposition of the two images stands as a metaphor for Rainer's own forty-year artistic and intellectual journey–a trajectory marked by the need to alternately return to and get beyond aesthetic impulses that were seemingly lost to more urgent social and ideological concerns.

Rainer, of course, was not alone in this pursuit, as a number of her contemporaries followed a similar aesthetic path in their quest for a socially responsible and responsive art. In the end, the art they have produced has represented one of the most vital links that the present-day art world has to the optimism and political and cultural vitality of the 1960s. Rather than regressive or limited, the vision of these artists continues to influence and shape the art world's most radical and progressive margins. As such, the work of these artists remains firm in its convictions and uncompromising in its formal and intellectual integrity–significant and noble attributes in an age of unparalleled cynicism and commercialism.

1 See, for example, Gregory Battcock,
 "Introduction," Lawrence Alloway, "Systemic
 Painting," Barbara Rose, "ABC Art," Irving
 Sandler, "Gesture and Non-Gesture in
 Recent Sculpture," in Battcock, ed., *Minimal
 Art: A Critical Anthology*, New York: E. P.
 Dutton, 1968, pp. 19-36, 37-60, 275-297,
 and 308-316.

2 Yvonne Rainer, "Statement" (program notes)
 for *The Mind Is a Muscle*, March 1968;
 reprinted in Rainer, *Work, 1961-73*, Halifax:
 Nova Scotia College of Art and Design, and
 New York: New York University, 1974, p. 71.

3 For more on the social milieu of the New
 Dance, see Sally Banes, *Democracy's Body:
 Judson Dance Theater, 1962-64*, Ann Arbor:
 UMI Research Press, 1983.

4 For more information on this subject, see
 Maurice Berger, *Labyrinths: Robert Morris,
 Minimalism, and the 1960s*, New York: Harper
 & Row, 1989; Lynn Zelevansky, *Sense and
 Sensibility: Women Artists and Minimalism in
 the 1990s*, New York: Museum of Modern
 Art, 1994.

5 For more on the above issues, see ibid.
and Maurice Berger, "Fragments: Homage
to a Woman Who...," in David Frankel, ed.,
*Sniper's Nest: Art that Has Lived with Lucy R.
Lippard*, Annondale-on-Hudson: Center for
Curatorial Studies, Bard College, 1996;
Lucy Lippard, *Eva Hesse*, New York: New
York University Press, 1976; Anna Chave,
"Minimalism and the Rhetoric of Power,"
Arts Magazine, January 1990, pp. 44-63;
and Judith Mastai, ed., *Social Process/
Collaborative Action: Mary Kelly, 1970-75*,
Vancouver, British Columbia: Charles H.
Scott Gallery, Emily Carr Institute of Art
and Design, 1997.

6 For more on Morris's antirepressive strate-
gies and his relationship to Brancusi, see
Berger, *Labyrinths*, pp. 47-79.

7 For more on Morris's relationship to
Marcuse and the New Left, see Berger,
Labyrinths, pp. 60-75, 92-101, 132-162.

8 Through his reading of Marcuse and his
interest in the transgressive, psychosexual
mind-body games of Marcel Duchamp,
Morris had come to see art as an important
vehicle of unrepressed erotic expression–from
a self-portrait composed of bodily fluids and
a construction of rubber membranes and
entitled "cocks and cunts" to the appearance
in his dance *Site* (1963) of the artist and
choreographer Carolee Schneemann nude
and posed in the manner of the prostitute
in Manet's *Olympia* and the naked lovers
(Morris and Rainer), their skin coated in oil,
their bodies locked in a slithery embrace,
who shimmy along a horizontal track in the
dance *Waterman Switch* (1965). See ibid.,
pp. 62-67.

9 Yvonne Rainer, "A Quasi Survey of Some
 'Minimalist' Tendencies in the Quantitatively
 Minimal Dance Activity Midst the Plethora,
 or an Analysis of Trio A," in Battcock,
 Minimal Art, pp. 266-273.

10 Ibid., p. 270.

11 For more on this subject, see Berger,
 Labyrinths, pp. 81-101.

12 Michael Fried, "Art and Objecthood," in
 Battcock, *Minimal Art*, p. 139. For more
 on Fried and the "theatricality" of art,
 see Stephen Melville, "Notes on the
 Reemergence of Allegory, the Forgetting
 of Modernism, the Necessity of Rhetoric,
 and the Conditions of Publicity in Art and
 Criticism," *October*, no. 19, Winter 1981,
 p. 65.

13 Fried, "Art and Objecthood," p. 120.

14 Ibid., p. 125.

15 Ibid.

16 Ibid., p. 128.

17 See, for example, Annette Michelson,
 "Robert Morris: An Aesthetics of
 Transgression," in *Robert Morris*,
 Washington, D.C.: Corcoran Gallery of Art,
 1969, pp. 7-79; Rosalind Krauss, *Passages in
 Modern Sculpture*, New York: Viking Press,
 1977, pp. 238-62; and Krauss, "Richard Serra
 in Translation," *The Originality of the Avant-
 garde and Other Modernist Myths*, Cambridge,
 Mass., and London: M.I.T. Press, 1985,
 pp. 260-74.

18 See Michelson, "Robert Morris," pp. 7-79.

19 Ibid., p. 42.

20 Peirce as quoted in ibid., pp. 43-44.

21 "It is [Morris's] commitment to the exact
 particularity of experience," concluded
 Michelson ("Robert Morris," p. 43), "to the
 experience of a sculptural object as inextrica-
 bly involved with the sense of self and that of
 space which is their common dwelling, which
 characterizes these strategies as radical."

22 It is important to acknowledge that the
 radicalism of minimalist dance and sculpture
 of the mid-1960s did not emerge out of
 experimental theater but rather the unusual
 convergence of the visual arts (including
 minimalist and conceptualist performance,
 fluxus environments, happenings, conceptual
 art, minimalist sculpture) with avant-garde
 dance. Marvin Carlson observes that the
 general shift away from "theater" to
 "performance" had already radically refigured
 the role of the viewer: "As theater moves
 more in the direction of performance art . . .
 the audience's expected 'role' changes from a
 passive hermeneutic process of decoding the
 performer's articulation, embodiment, or
 challenge of particular cultural material, to
 become something more active, entering into
 a praxis, a context in which meanings are not
 so much communicated as created,
 questioned, or negotiated. The 'audience'
 is invited and expected to operate as a
 co-creator of whatever meanings and
 experience the work generates." See Marvin

Carlson, *Performance: A Critical Introduction*, New York and London: Routledge, 1996, pp. 197-98.

23 For an important introduction to the concept of the "performative," see Andrew Parker and Eve Kosofsky Sedgwick, *Performativity and Performance*, New York and London: Routledge, 1995.

24 Ibid., pp. 13-14.

25 For more on Haacke's attitudes about minimalism, see Jeanne Siegel, "Hans Haacke: Systems Aesthetics" (Interview), in Siegel, ed., *Artwords: Discourse on the '60s and '70s*, Ann Arbor: UMI Research Press, 1985, pp. 213-14, and Yve-Alain Bois, Douglas Crimp, and Rosalind Krauss, "A Conversation with Hans Haacke," *October*, no. 30, Fall 1984, pp. 24-28.

26 For more on these works, including Haacke's commentary on them, see Brian Wallis, ed., *Hans Haacke: Unfinished Business*, New York: The New Museum of Contemporary Art, and Cambridge, Mass., and London: M.I.T. Press, 1984, pp. 86-87, 98-105, 252-55.

27 Adrian Piper, "Xenophobia and the Indexical
 Present II: Lecture" (1992) in Piper, *Out of
 Order, Out of Sight: Volume 1: Selected Writings
 in Meta-Art, 1968-1992*, Cambridge, Mass.,
 and London: M.I.T. Press, 1996, pp. 267.

28 According to Piper, these exercises were
 directly co-extensive with the perceptual
 experiments of minimalist artists, choreogra-
 phers, and filmmakers such as LeWitt,
 Rainer, Morris, and Michael Snow. See
 Maurice Berger, "Black Skin, White Masks:
 Adrian Piper and the Politics of Viewing,"
 in *How Art Becomes History: Essays on Art,
 Society and Culture in Post-New Deal America*,
 New York: HarperCollins, 1992, pp. 95-96.

29 Piper writes: "I traumatized myself, burned
 out, and began to withdraw from the art
 world into the external world. The political
 upheavals of 1970 . . . [as well as] others'
 responses to my perceived social, political,
 and gender identity braked my flight a bit.
 I struggled to understand both. I plummeted
 back to earth, where I landed with a jolt."
 See Piper, "Flying," in *Adrian Piper:
 Reflections, 1967-1987*, New York:
 The Alternative Museum, 1987, p. 21.

30 Piper, "Xenophobia and the Indexical
 Present II: Lecture," p. 257.

31 Yvonne Rainer, "The Performer as a
 Persona," *Avalanche*, Summer 1972, p. 50;
 as quoted in Carlson, *Performance*, p. 147.

32 On the relationship of feminism to
 performance, see Kathy O'Dell, *Contract
 with the Skin: Masochism, Performance Art,
 and the 1970s*, Minneapolis: University
 of Minnesota Press, 1998; Sue-Ellen Case,
 Feminism and Theater, New York: Methuen,
 1988; and Moira Roth, "Autobiography,
 Theater, Mysticism, and Politics: Women's
 Performance Art in Southern California,"
 in Carl Loeffler and Darlene Tong, eds.,
 Performance Anthology, San Francisco: Last
 Gasp Press, 1989, pp. 460-70; and Carlson,
 Performance, pp. 144-54.

33 Mary Kelly, "Re-viewing Modernist
 Criticism," *Screen*, vol. 22, no. 23, 1981;
 reprinted in Kelly, *Imaging Desire*,
 Cambridge, Mass., and London: M.I.T.
 Press, 1996, p. 93.

34 Thus when the artist Gene Pane painfully
mutilated herself in the act of performance,
her action, according to Kelly, was "more a
matter of phenomenology than metaphysics;
an aesthetics of lived experience . . . [was]
being counterpoised to that of the object."
See ibid., pp. 95-96. Kelly is basing her
analysis of Pane on Judith Barry and Sandy
Flitterman, "Textual Strategies–The Politics
of Art Making," *Screen*, vol. 21, no. 2,
Summer 1980, pp. 37-38.

35 Kelly, "Introduction," in *Imaging Desire*,
pp. xx-xxi.

36 While such avant-gardist strategies can
be seen as elitist and irrelevant to the social
praxis, they must be understood in the
context of the period in which they were
produced. Rather than examples of direct
political activism, Kelly's theoretical femi-
nism must be understood in opposition to
the sexist and racist modernist agenda that it
is ultimately challenging. Kelly's conceptual
and ideological position refuses to cede the
avant-garde to the realm of straight white
male authority. "The 'look' of political art of

this generation," writes Griselda Pollock, "has . . . puzzled many commentators. It was sophisticated, theorized, and self-consciously attached to a modernist and, importantly, a critically modernist tradition. These 'strategic practices' have been castigated for elitism and a lack of political authenticity by the populist elements in the women's movement. To a lesser extent, they could be classified and dismissed as merely adventurous signs of emergent postmodernism. It is only a continuing sense of the historical formations of these strategic practices which can ensure their comprehension amidst these two massive misrecognitions." See Griselda Pollock, "Histories," in Mastai, ed., *Social Process/ Collaborative Action: Mary Kelly, 1970-75*, p. 46. For more on the *Document* itself, see Mary Kelly, *Post-Partum Document*, London and Boston: Routledge & Kegan Paul, 1983, and Laura Mulvey, "'Post-Partum

Document' by Mary Kelly," in Roszika
Parker and Griselda Pollock, eds., *Framing
Feminism: Art and the Women's Movement,
1970-1985*, London and New York:
Pandora, 1987, pp. 97-123.

37 For an excellent interview with Rainer, see
Thyrza Nichols Goodeve, "Rainer Talking
Pictures," *Art in America*, vol. 85, no. 7,
July 1997, pp. 56-63, 104.

A

CONTINUUM

OF

WORDS

AND

IMAGES

HANS HAACKE

MARY KELLY

ROBERT MORRIS

ADRIAN PIPER

YVONNE RAINER

Comparing the dance to Minimal Art
provided a convenient method of organization.
Omissions and overstatements are a hazard
of any systematizing in art. I hope that
some degree of redress will be offered by
whatever clarification results from this essay.

Yvonne Rainer, "A Quasi Survey of Some 'Minimalist'
Tendencies in the Quantitatively Minimal Dance Activity
Midst the Plethora, or an Analysis of Trio A" (1966)

Just as ideological issues have no bearing
on the nature of [this dance] work, neither
does the tenor of current political and social
conditions have any bearing on its execution.
The world disintegrates around me. My
connection to the world-in-crisis remains
tenuous and remote.

Yvonne Rainer, program notes
for The Mind Is a Muscle (1968)
from Work 1961-73

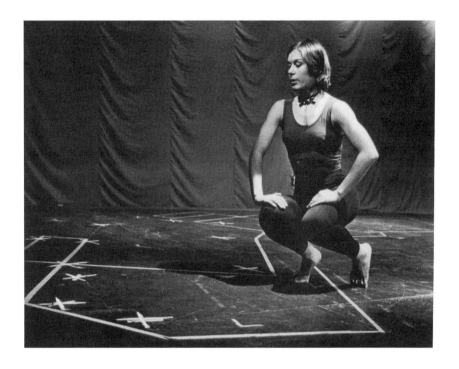

Dance still from Yvonne Rainer,
At my Body's House,
Solo performance for Surplus Dance Theater, 1964
black *&* white photograph, 8 x 10 in.,
@ Peter Moore, estate of Peter Moore

*Eighty percent of air attacks against North
Vietnam were being flown from bases in
Thailand across Laotian air space, guided to
their targets by American-manned radar
bases in Laos, the bombs actually dropped by
electronic signals from these bases. If the
U.S. had the right to use Laotian air space
to attack North Vietnam, did not the North
Vietnamese have the right to cross Laotian
ground space to hit back at the bases in
Thailand—not to mention the right of entering
Laotian territory to wipe out radar bases?*

*Yvonne Rainer, text read by narrator during
performance of Rainer's dance piece* War *(1970)*

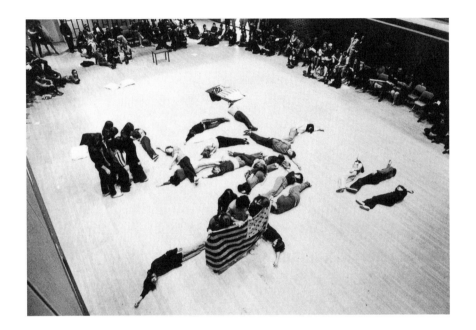

Dance still from Yvonne Rainer,
War,
Performance at Loeb Student Theater, 1970
black & white photograph, 8 x 10 in.,
@ Peter Moore, estate of Peter Moore

A very important difference between the work of Minimalist sculptors and my work is that they were interested in inertness, whereas I was concerned with change. From the beginning the concept of change has been the ideological basis of my work. All the way down there's absolutely nothing static–nothing that does not change. Most Minimal work disregards change. Things claim to be inert, static, immovably beyond time. But the status quo is an illusion, a dangerous illusion politically.

Hans Haacke, "Hans Haacke: Systems Aesthetic"
(Interview with Jeanne Siegel, 1971)

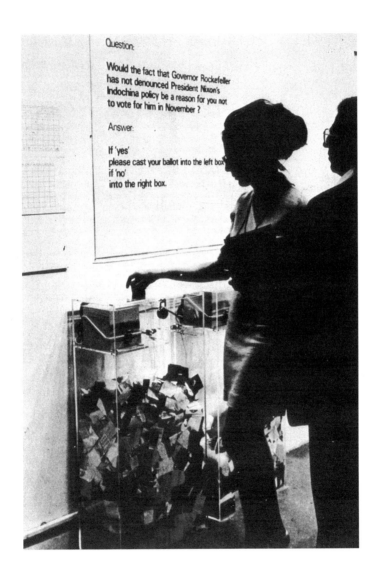

MOMA Poll, 1970,
installation, 2 transparent acrylic
ballot boxes, 40 x 20 x 10 in. each,
collection of the artist

Although [the critic Michael] Fried referred to the minimal object as having "stage presence," in effect it remained no more than a prop without the intervention of the actor/artist and his script. Ultimately, it became both necessary and expedient for the artist to stage himself; necessary because it was logically bound up with the interrogation of the object, and expedient because at the same time it rescued a semblance of propriety for ephemeral art forms.

Mary Kelly, "Re-Viewing Modernist
Criticism" (1981)

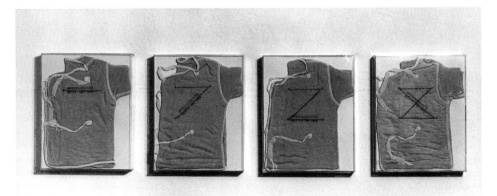

Post Partum Document Introduction, 1973,
4 mixed media units, 10 x 8 in. each,
collection of the artist
(photograph: Ray Barrie)

Under attack is the rationalist notion that art is a form of work that results in a finished product. Duchamp, of course, attacked the Marxist notion that labor was an index of value, but readymades are traditional, iconic art objects. What art now has in its hands is the mutable stuff which need not arrive at a point of being finalized with respect to either time or space. The notion that work is an irreversible process ending in a static icon-object no longer has much relevance.

Robert Morris, "*Notes on Sculpture, Part IV: Beyond Objects*" (1969),
in Continuous Project Altered Daily

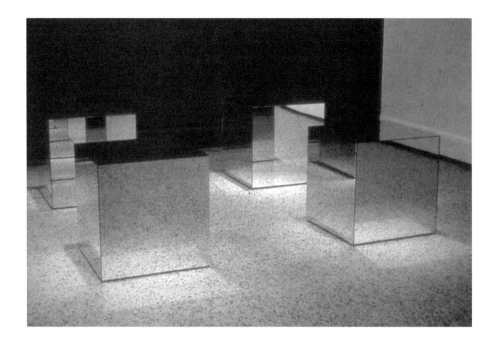

Untitled, 1965,
glass mirrors on wood cubes,
24 x 24 x 24 in. each,
collection of the artist

The reemergence of self-consciously distanced,
critical art with explicit social content in the early
1970s, then, was a natural outgrowth of the
reaffirmation of content latent in minimalism
and the self-reflexive subject-matter explicit in
conceptual art. The cognitive and formal strategies
of minimalism, and their evolution in the work
of Sol LeWitt and first-generation conceptualists,
reestablished the link with European modernism
by restoring distanced self-awareness as a central
value of artistic production–a self-awareness
that is inevitably as social, cultural, and political
as it is formal in its purview.

Adrian Piper, *"The Logic of Modernism"* (1993),
in Out of Order, Out of Sight

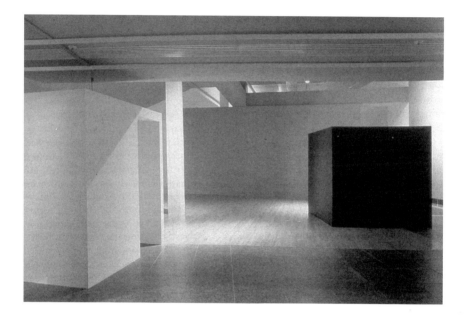

Black Box/White Box, 1992,
mixed media installation,
installation view, 96 x 96 x 96in. each
(photograph: Wexner Center for the Arts)

*As you see, one can recycle "minimalism" and put it
to contemporary use. I admit that I have always
been sympathetic to so-called minimal art. That does
not keep me from criticizing its determined aloof-
ness, which, of course, was also one of its greatest
strengths. As to the implied incompatibility between
a political statement/information and a work of art,
I don't think there are generally accepted criteria
for what constitutes a work of art. At least since
Duchamp and the constructivists, this has been a
moving target. On a more popular level, of course,
there are strong feelings about what does or does
not look like a work of art. Minimal cubes obviously
don't qualify, whereas anything on canvas is
unquestionably accepted. The argument rages only
about whether or not it is a good work.*

Hans Haacke, "A Conversation with Hans Haacke"
(Interview with Yve-Alain Bois, Douglas Crimp,
and Rosalind Krauss, 1984)

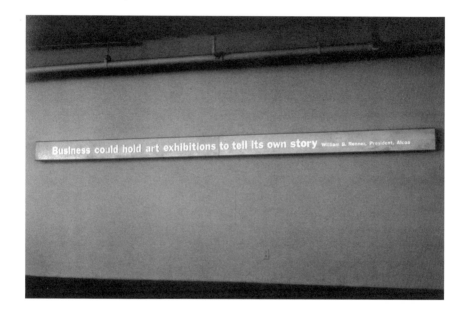

Alcoa: We can't wait for tomorrow, 1979,
polished aluminum mirror, square aluminum
tubing letters, 9 x 192 x 4 1/2 in.,
private collection (photograph: John A. Ferrari)
artwork not included in exhibition

At that time (1972) I was doing a kind of parody of narrative. The performers read self-consciously from a script. It was a very distantiated kind of narrative. Then I would set up these tableaux of minimal situations all in that barren space that could be dressed with a chair or a suitcase to refer to a history of melodramatic objects and usage. So it was very strange and artificial. When I talk about narrative now, I'm talking about the way it is done.

Yvonne Rainer, on her first film Lives of Performers,
Mitchell Rosenbaum, "Interview with Yvonne Rainer"
(1989), in The Films of Yvonne Rainer

Journeys From Berlin/1971, 1980,
16mm, color and black & white film,
sound (photograph: Zeitgeist Films, Ltd.)

*Political art presents the extra challenge of
presenting content that is accessible, on the one
hand, but sophisticated or ironic, on the other.
Sometimes people don't see the humor because
the content pushes their buttons, or don't see
the complexity because it is too difficult to think
clearly about the issues. I think that these matters
depend very much on the viewer's prior level of
sophistication or knowledgability, the extent to
which one has thought about these issues or has
encountered them personally. As a minimalist
and conceptualist, my basic aesthetic values are
clarity and simplicity. These help, but as we
all know, one cannot reach all of the people all
of the time.*

*Adrian Piper, "Xenophobia and the Indexical Present II:
Lecture" (1992), in* Out of Order, Out of Sight

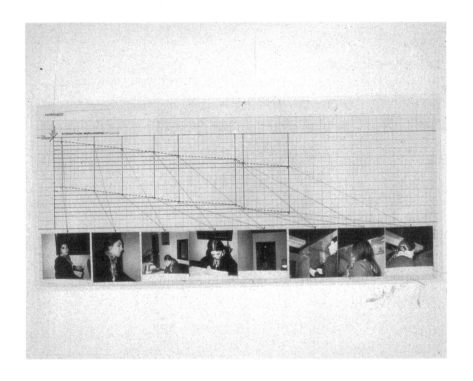

"Situation" from *Hypothesis* series, 1969-70,
photo chart collage, sizes variable,
collection of the artist

Following the paradoxical logic of modernism's demand
for objective purposes as well as transcendental truths,
avant-garde practices between 1965 and the mid-1970s
initiated areas of work that divided the very field
of which they were an effect. The potential of that
divergence has not been completely realized. First,
the materiality of the practice: initially defined in terms
of the constraints of a particular medium, it must now
be defined as a specific production of meaning. Second,
sociality, raised as the question of context, is the gallery
system (inside versus outside), and the commodification
of art (object versus process, action, idea, etc.). This
must be reconsidered as the question of institutions,
of the conditions which determine the reading of artistic
texts and the strategies which would be appropriate for
interventions (rather than "alternatives") in that con-
text. Third, sexuality, posed as the problem of images of
women and how to change them, must be reformulated
as a concern with positionality, with the production of
readers as well as authors for artistic texts and crucially,
with the sexual overdetermination of meaning which
takes place in the process.

Mary Kelly, "Re-Viewing Modernist Criticism" (1981)

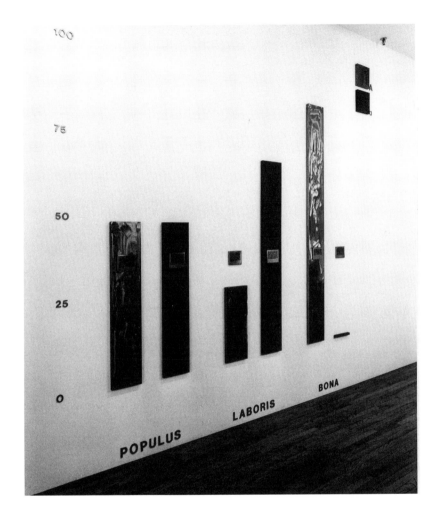

Potestas, 1989,
brass and steel etching, 100 x 114 in.,
collection of the New Museum of
Contemporary Art, New York

*All art is political and in the taking of it and
the making of it . . . you cannot avoid the fact
that it's . . . involved in a class situation. . . .
Most of modern art itself is a very bourgeois
undertaking, and we may have very. . . strong
critical feelings about how this whole enterprise
proceeds along; nevertheless we have a good
deal of allegiance to the kinds of structures and
intentions and investigations and changes that
have happened within this class structure.
There are a lot of oppressive . . . factors built
into the way the art world moves along,
irrespective of the sensibility of the invention
going on.*

Robert Morris, "Robert Morris [New York 1972],"
Interview in Achille Bonito Oliva, Dialoghi d'artista:
Incontri con l'arte Contempronea, 1970-1984

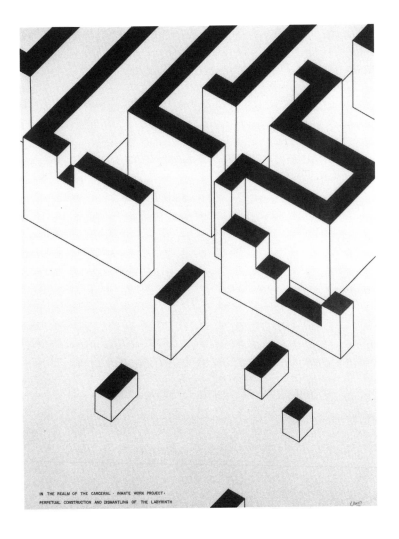

*In the Realm of the Carceral, Inmate
Work Project, Perpetual Construction
and Dismantling of the Labyrinth,* 1978,
ink drawing on paper, 45 x 33 3/4 in.,
collection of the artist
(photograph: Bevan Davies)

. . . I believe the use of the term "industry" for the entire range of activities of those who are employed or working on a freelance basis in the art field has a salutary effort. With one stroke that term cuts through the romantic clouds that envelop the often misleading and mythical notions widely held about the production, distribution, and consumption of art. Artists, as much as galleries, museums, and journalists (not excluding art historians), hesitate to discuss the industrial aspect of their activities. An unequivocal acknowledgment might endanger the cherished romantic ideas with which most art world participants enter the field. . . . Those who in fact plan and execute industrial strategies tend, whether by inclination or need, to mystify art and conceal its industrial aspects and often fall for their own propaganda. Given the prevalent marketability of myths, it may sound almost sacrilegious to insist on using the term "industry."

Hans Haacke, *"Museums, Managers of Consciousness"* (1986),
in Brian Wallis, Hans Haacke: Unfinished Business

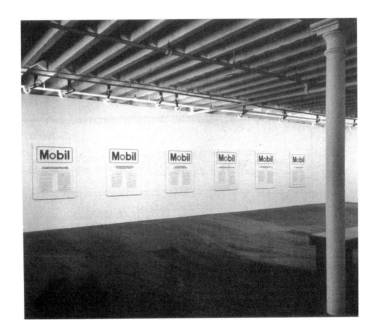

The GoodWill Umbrella, May 1976,
6 silkscreen on acrylic panels,
48 x 36 in.,
collection of the artist

Artists' lives are bound within the repressive structure of the art world: The iron triangle is made up of museums, galleries, and the media. All three . . . wield power over artists while maintaining a symbiotic dependence on them. In almost every case status quo economic interests support this iron triangle and effective policies coming from each corner of it. The repressive structures within the art world parallel those outside it. But while this should generate protest action on a broad front it has not done so until recently Primarily, artists want to be left alone to do their work and consequently they do not develop political consciousness but prefer instead a paternalistic patronage and support.

Robert Morris, Unpublished essay on art and politics (1970)

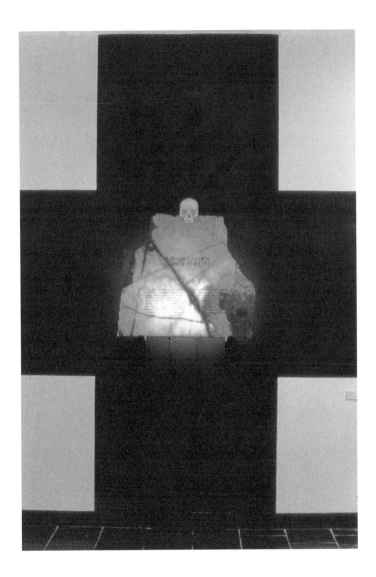

"Cenotaph," from *Preludes (for A.B.)*, 1980,
mixed media, size variable to site,
collection of the artist

For a white audience, [my work] often has a didactic function. It communicates information and experiences that are new, or that challenge preconceptions about oneself and one's relation to blacks. For a black audience, the work often has an affirmative or cathartic function: It expresses shared emotions–of pride, rage, impatience, defiance, hope–that remind us of the values and experiences we share in common. . . . Whether particular individuals feel attacked . . . affirmed . . . or challenged [by my work], it can teach them something about who they are.

Adrian Piper, *"General Statement About My Art" (n.d.),*
in Out of Order, Out of Sight

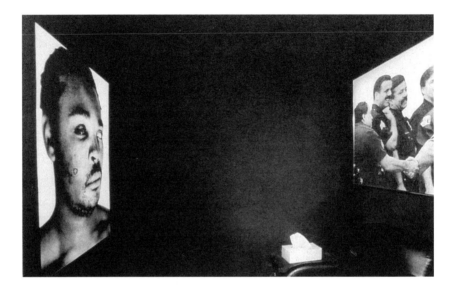

Black Box / White Box, 1992,
mixed media installation,
installation view, 96 x 96 x 96 in. each
(photograph: Wexner Center for the Arts)

. . . Feminism did not generate a unified aesthetic. Nevertheless, it infiltrated or overtly influenced every art- (or un-art-) making process of that moment in distinct and irreversible ways: notably, by transforming the phenomenological presence of the body into an image of sexual difference, extending the interrogation of the object to include the subjective conditions of its existence, turning political intent into personal accountability, and translating institutional critique into the question of authority. In this sense, feminism's impact was not marginal but central to the formation of modernism's "post" condition.

Mary Kelly, "Remembering,
Repeating, and Working-Through" (1995),
in Imaging Desire

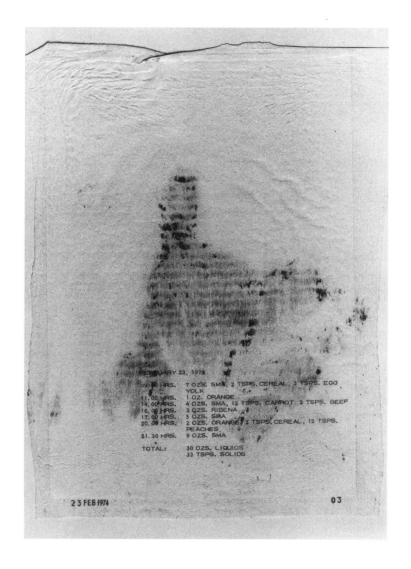

Post Partum Document Prototype, 1974,
1 of 28 units, mixed media, 14 x 11 in.,
collection of the Art Gallery of Ontario,
Canada

Passing from the realm of the theory of the subject to the shifty spaces of feminine writing is like emerging from a horror movie to a costume ball. The world of "theorization" is a grim one, haunted by mad scientists breeding monsters through hybridization, by the haunted ghosts of a hundred isms, and the massive shadow of the subject surging up at every turn. Feminine writing lures with an invitation to license, gaiety, laughter, desire, and dissolution, a fluid exchange of partners of indefinite identity. All that custom requires is infinite variety, infinite disguise. Only overalls are definitely out of place [dance music fades up]; this is the world of "style." Women are not welcomed here garbed in the durable gear of men; men, instead, get up in drag.

The character of "Jackie" speaking in Yvonne Rainer's
film The Man Who Envied Women (1985), in
The Films of Yvonne Rainer

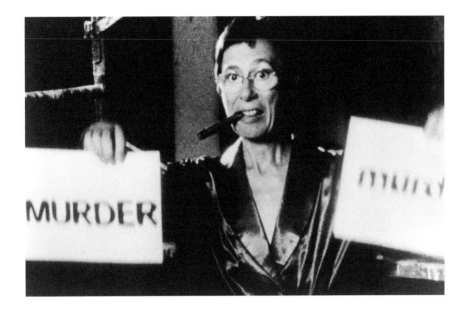

MURDER and murder, 1996,
16mm, color and black & white film,
sound (photograph: Esther Levine)

MAURICE BERGER

MINIMAL POLITICS
1965–1995

A
TIMELINE
ON
ISSUES
OF
AMERICAN
POLITICS,
RACE,
GENDER,
AND
SEXUALITY

*This timeline lists some of the events
that have served as the backdrop to or
impetus for radical and avant-garde
cultural activity in the United States
during the period explored in this book
and exhibition. Rather than implying
a direct correlation between event and
art object, however, the chronology
is meant as an historical supplement
to this project, a point of departure
for considering some of the social and
cultural issues and activist positions
articulated in the work of Hans
Haacke, Mary Kelly, Robert Morris,
Adrian Piper, and Yvonne Rainer.*

1965

POLITICS

—— President Lyndon B. Johnson
initiates "The Great Society"
program.

—— U.S. involvement in Vietnam
conflict escalates.

—— First "Teach-Ins" are held
at the University of Michigan
(Ann Arbor).

—— Cultural Revolution
commences (China).

—— U.S. Marines land in
Dominican Republic.

RACE GENDER AND SEXUALITY

—— Voting Rights Act —— Feminist activists within
 Students for a Democratic
—— Race riot (Los Angeles) Society (SDS) raise issue
 of women's rights.
—— Assassination: Malcolm X
(New York)

1966

POLITICS

First major protests against U.S.
involvement in the Vietnam War

RACE	GENDER AND SEXUALITY

—— First African-American senator since Reconstruction: Edward Brooke (R., Massachusetts)

—— Black Panther Party (Oakland, California)

—— Rev. Martin Luther King, Jr., comes out in opposition to U.S. Vietnam policy.

—— National Organization for Women (NOW)

—— Gay men, lesbians, and members of the clergy demonstrate against unfair hiring practices (Washington, D.C.).

1967

POLITICS

—— Pentagon is sieged by
antiwar activists.

—— Psychedelic "Summer of Love"
(San Francisco)

—— Arab-Israeli "Six Day War"

—— People's Republic China
explodes its first hydrogen bomb.

RACE GENDER AND SEXUALITY

—— Race riots (Newark; Detroit) —— Police raids on gay bars
 prompt street demonstrations
—— First African-American (Los Angeles).
U.S. Supreme Court Justice:
Thurgood Marshall

—— First black mayors of major
U.S. cities: Carl B. Stokes
(D., Cleveland) and Richard
G. Hatcher (D., Gary,
Indiana)

1968

POLITICS

——— Tet Offensive (Vietnam); 525, 000
U.S. troops in Southeast Asia;
Paris peace talks commence.

——— Student uprising at Columbia
University (New York)

——— Presidential election: President
Lyndon Johnson withdraws
from race; Democratic convention
is rocked by violent protests
(Chicago); Republican Richard M.
Nixon is elected president
by a slim margin.

——— Assassination: Senator Robert
Kennedy (Los Angeles)

——— Czechoslovakia is invaded
by Russians.

RACE

GENDER AND SEXUALITY

Assassination: Rev. Dr. Martin
Luther King, Jr. (Memphis)

First black woman elected to
U.S. Congress: Rep. Shirley
Chisholm (D., New York)

The National Advisory
Committee on Civil Disobedience
reports that an irreconcilable
political schism exists between
whites and blacks resulting from
adverse effects of white racism on
"separate but unequal" African
Americans. This division is cited
as the major cause of racial
tension and riots in U.S.

Tommie Smith and John Carlos
raise their fists in a Black Power
salute while receiving their medals
at the Olympics and are subse-
quently suspended from the U.S.
Olympic team (Mexico City).

First African-American network
television character not engaged
in menial labor: Dianne Carroll
(TV series "Julia")

*Voice of the Women's Liberation
Movement*, a newsletter, begins
publication.

Women's Equity Action League

1969

POLITICS

— President Richard M. Nixon
announces Vietnam peace offer;
massive antiwar demonstrations
in U.S. result.

— End of Cultural Revolution
(China)

— Students for a Democratic Society
(SDS) disbands.

— Woodstock music festival
(New York)

— U.S. puts man on the moon.

— "Days of Rage" (Chicago)

— Trial of the "Chicago Eight"

RACE	GENDER AND SEXUALITY

U.S. Commission on Civil Rights report blames administration of President Richard Nixon for a slow, misguided desegregation policy.

First major post–World War II film directed by an African American: *The Learning Tree* (Gordon Parks)

Three New York radical feminist groups are formed: the Feminists, the Redstockings, and the New York Radical Feminists.

First university-level women's study program: Cornell University

FBI initiates an investigation of the women's movement for possible subversive activities.

Stonewall uprising signals the beginning of the gay rights movement in the United States (New York).

Gay Liberation Front (GLF) and Gay Activist Alliance (GAA)

1970

POLITICS

— U.S. invades Cambodia.

— U.S. Senate repeals Gulf
of Tonkin resolution.

— Four students are killed by state
troopers during a protest rally
at Kent State University (Ohio).

— Biafra surrenders after fight for
independence from Nigeria.

RACE GENDER AND SEXUALITY

— FBI director J. Edgar Hoover,
claiming that black militant
groups in the United States
are "infiltrated" by foreign
influences, undertakes a major
destabilization plan of these
organizations.

— While the African-American
consumer market amounts to
more than $30 billion a year,
only three of the more than
3,000 senior officers at the top
U.S. corporations are African
American.

— U.S. Equal Employment
Opportunity Commission
defines and prohibits
sexual harassment.

— First states to liberalize
abortion laws: Hawaii,
Alaska, and New York

— U.S. Senate holds hearing on
an Equal Rights Amendment
to the Constitution for women.

— National Women's Strike for
Equality (New York)

— Women, Students, and Artists
for Black Art Liberation
(WSABAL)

— *Off Our Backs, Ain't I a Woman?*
and *It Ain't Me, Babe,* feminist
journals, begin publication.

— Gay Activist Alliance protests
at various political functions in
order to bring about a national
awareness of gay political issues.

1971

POLITICS

—— U.S. Congress bars use of combat troops, but not air power, in Laos and Cambodia.

—— *New York Times* publishes classified "Pentagon Papers."

—— Militant antiwar protests; 12, 000 are arrested (Washington, D.C.).

—— Deadly uprising rocks Attica Prison (New York).

—— Constitutional amendment lowering the voting age to 18 in all elections is ratified

—— U.N. seats People's Republic of China.

RACE

GENDER AND SEXUALITY

People United to Save Humanity (P.U.S.H.) is organized by Rev. Jesse Jackson to combat poverty and encourage community development (Chicago).

New York Radical Feminists organizes a "Speakout Against Rape"

Women's studies curriculum is introduced into public high schools (Berkeley, California).

Congressional Black Caucus

National Women's Political Caucus

FBI infiltrates Washington, D.C., area chapters of the Gay Liberation Front and the Gay Action Alliance.

1972

POLITICS

—— President Nixon orders
"Christmas bombing"
of North Vietnam.

—— Presidential election: liberal,
antiwar Sen. George McGovern
(D., South Dakota) is defeated
by conservative Republican
President Richard Nixon.

—— President Nixon makes
unprecedented visit to
People's Republic of China.

—— Five men are apprehended by
police during attempt to "bug"
Democratic National Committee
headquarters; Watergate scandal
begins (Washington, D.C.).

—— U.S. Supreme Court declares
death penalty unconstitutional.

RACE

GENDER AND SEXUALITY

—— Coalition Against Blax-
ploitation, a consortium
of civil rights groups, calls
attention to the rising
number of Hollywood films
that perpetuate destructive
or negative images of
African-American life.

—— U.S. Senate sends to states
for ratification an Equal Rights
Amendment to the Constitution
banning discrimination against
women.

—— Equal Employment Opportunity
Act prompts legal proceedings
against sexual discrimination.

—— National Conference
of Puerto Rican Women

—— *Ms.* magazine is founded.

—— Prostitutes organize into a union,
COYOTE (Cut Out Your Old
Tired Ethics).

1973

POLITICS

—— U.S. military draft is ended.

—— Last U.S. ground troops
leave Vietnam.

—— President Salvador Allende is
overthrown and killed (Chile).

—— U.S. oil crisis

—— Vice-President Spiro T. Agnew
resigns.

RACE	GENDER AND SEXUALITY

—— Wounded Knee massacre

—— U.S. Supreme Court rules in *Roe v. Wade* that a state may not prevent a woman from having an abortion during the first six months of pregnancy.

—— National Black Feminist Organization

—— NOW organizes a National Task Force on Sexuality and Lesbianism

—— National Abortion Rights Action League (NARAL)

—— National Gay Task Force (NGTF) and Lambda Legal Defense and Education Fund

1974

POLITICS

— North and South Vietnam
accuse each other of cease-fire
violations.

— Heiress Patricia Hearst is
kidnapped by the Symbionese
Liberation Army.

— U.S. House Judiciary
Committee hands down
articles of impeachment
against President Nixon;
the next day, he becomes
the first president to resign;
President Gerald R. Ford
grants "full, free, and
absolute" pardon to Nixon.

RACE

GENDER AND SEXUALITY

—— U.S. Justice Department
memos confirm that the
FBI waged disruptive
campaigns against black
nationalist groups in
the 1960s.

—— University of Pennsylvania
study indicates that whites
outscore blacks on intelli-
gence tests because of
environmental factors
rather than biological
differences; the white-
content bias of these tests
favors people raised in
a white environment.

—— First African-American
fashion model to appear
on the cover of *Vogue*:
Beverly Johnson

—— First black manager in
major league baseball:
Frank Robinson
(Cleveland Indians)

—— Coalition of Labor Union
Women (CLUW)

—— Association of Mexican
American Women

—— First woman governor
elected in her own right:
Ella Grasso (D., Connecticut)

—— Lesbian Herstory Archives
(New York)

—— Demonstrators at the
Los Angeles Times demand
positive coverage of lesbians
and gay men.

1975

POLITICS

—— Full-scale war resumes in
Vietnam; communists are
victorious.

—— Assassination attempt:
President Gerald Ford

RACE GENDER AND SEXUALITY

— Wallace D. Muhammad — American Indian Women's
 succeeds his father Elijah Leadership Conference
 Muhammad as the leader (New York)
 of the Nation of Islam; he
 later opens the Nation to — First women's bank
 people of all races. (New York)

 — First feminist conference
 on health: Our Bodies,
 Ourselves (Harvard)

 — United Nations designates
 International Year of the
 Woman; UN Conference
 held in Mexico City.

 — American Psychological
 Association removes
 homosexuality from its
 list of mental disorders.

1976

POLITICS

—— Federal Election Campaign Act

—— U.S. Supreme Court rules
that the death penalty is not
inherently cruel or unusual
and is a constitutional form
of punishment.

—— U.S. celebrates Bicentennial.

—— Mao Zedong dies (Peking).

RACE GENDER AND SEXUALITY

— First black president of the — The General Convention
U.S. Conference of Mayors: of the Episcopal Church
Kenneth Gibbon (Newark) announces support of the
 ordination of women.

— College enrollment has risen
among African Americans from — President Ford vetoes
282, 000 in 1966 to 1,062, 000. comprehensive child-care bill.

 — NOW appoints a task force
 on domestic violence.

 — National Alliance of Black
 Feminists (Chicago)

1977

POLITICS

— President Jimmy Carter
pardons most Vietnam
War draft evaders.

— Nuclear-proliferation pact
is signed by 15 nations,
including U.S. and USSR.

RACE GENDER AND SEXUALITY

—— First black Secretary of —— First U.S. Congressional
the U.S. Army: Clifford Women's Caucus
Alexander, Jr.

—— U.S. Congress, in "Hyde
Amendment," prohibits use
of federal Medicaid money
for abortions.

—— National Women's Study
Association

—— Entertainer Anita Bryant
begins her anti-gay "Save
Our Children" campaign
(Dade County, Florida).

—— New York City Gay
Liberation Day march
swells to 75,000 from
15,000 the previous year.

1978

POLITICS

—— U.S. Congress, in Humphrey-Hawkins bill, sets national goals to reduce unemployment and inflation.

—— U.S. Senate confirms Panama Canal neutrality treaty.

—— Californians approve referendum to slash property taxes by 60 percent.

—— Rhodesian government agrees to transfer to black majority rule.

RACE GENDER AND SEXUALITY

—— U.S. Supreme Court rules —— U.S. Congress votes five-year
that firm quota systems in extension of ERA ratification
affirmative action plans are deadline.
unconstitutional.

 —— National Feminist Lesbian
 Organization

 —— Assassination: gay activist
 Harvey Milk (San Francisco)

1979

POLITICS

— Militant Muslim leader
Ayatollah Khomeini takes
power; Iranian militants
seize U.S. embassy in
Teheran (Iran).

— Conservatives win British
election; Margaret Thatcher
becomes new Prime Minister.

— Nuclear power plant
accident (Three Mile Island,
Pennsylvania)

— Soviet invasion of Afghanistan

RACE

GENDER AND SEXUALITY

U.S. Census Bureau reports
that African Americans remain
far behind whites in employ-
ment, income, health, housing,
and political power.

B'nai B'rith Anti-Defamation
League reports a sharp
increase in KKK activities in
the United States.

National Abortion Rights Week

Wayne Lee is beaten by
three U.S. Army Rangers for
alleged homosexual advances
in an adult bookstore (Savannah,
Georgia).

Start of the right-wing
"pro-family" movement

1980

POLITICS

— First noncommunist govern-
ment in Eastern Europe: Poland

— U.S. withdraws from Moscow
Olympics to protest Soviet
invasion of Afghanistan.

— Civil war in El Salvador

— Ronald Reagan is elected
president of the United States.

RACE GENDER AND SEXUALITY

—— Race riot (Miami)

—— First black cable television
network: Black Entertainment
Television

—— First black public-broadcasting
station: WHMM (Howard
University, Washington, D.C.)

—— Democratic National
Convention achieves
equal representation
of both sexes.

—— U.S. Census stops defining
the Head of Household as
the husband.

—— Feminist Hispanic conference
(San Jose, California)

1981

POLITICS

—— American hostages are
released from Iran.

—— Attempted assassinations:
President Ronald Reagan
and Pope John Paul II

—— Martial law is declared
in Poland.

RACE	GENDER AND SEXUALITY

— U.S. Department of Labor confirms that black unemployment, at 14 percent, is nearly double that for whites.

— President Reagan's conservative policies will begin to erode U.S. civil rights for women and people of color.

— More than 300, 000 demonstrators from labor and civil rights organizations participate in a Solidarity Day March to protest the social policies of the Reagan administration (Washington, D.C.).

— First woman Justice of the U.S. Supreme Court: Sandra Day O'Connor

— Women in the U.S. earn $.59 for every dollar earned by men.

— Gay Men's Health Crisis (GMHC)

1982

POLITICS

—— Vietnam War Memorial
(Washington, D.C.)

—— U.S. Department of Labor
reports highest unemployment
rate since 1940

—— British overcome Argentina
in Falklands war.

RACE GENDER AND SEXUALITY

——— U.S. Congress extends the ——— The Equal Rights Amendment
1965 Voting Rights Act for for women is defeated after a
an additional 25 years. 10-year struggle for ratification.

——— Census Bureau reports that ——— First state Gay Rights Bill:
the poverty rate for African- Wisconsin
Americans is 36 percent as
compared to the national
average of 14 percent.

——— U.S. Senate passes bill that
virtually eliminates busing
for purposes of racial
desegregation.

1983

POLITICS

— U.S. invades Caribbean island of Grenada.

— National Commission on Excellence in Education labels U.S. elementary and secondary schools "mediocre."

— U.S. admits shielding former Nazi Gestapo chief Klaus Barbie.

— Terrorist explosion kills 237 U.S. Marines in Beirut.

RACE GENDER AND SEXUALITY

—— U.S. Commission on Civil
Rights charges that Reagan
Administration weakened
governmental civil rights
enforcement.

—— U.S. Supreme Court rules
that the Internal Revenue
Service can deny tax exemp-
tions to private schools that
practice racial discrimination.

—— First African-American Miss
America: Vanessa Williams
(New York); she is later forced
to resign after the revelation
that she had once posed for
nude photographs.

—— U.S. Commission on Civil
Rights criticizes President
Reagan for failing to
appoint more women and
minorities to high-level
positions in the federal
government.

—— U.S. Supreme Court
reaffirms women's right
to an abortion and, in
another ruling, forbids
sexual discrimination
in retirement plans.

—— National Council
of Churches publishes
a collection of
antisexist biblical texts.

—— First American woman to
travel in space: Sally Ride

1984

POLITICS

—— U.S. Senate rejects two
Constitutional Amendments
that would have permitted
prayer in public schools.

—— President Reagan ends U.S.
peace-keeping role in Beirut.

—— Moderate José Napoleón
Duarte elected president
of El Salvador

—— Toxic gas leak at Union
Carbide plant kills 2, 000
(Bhopal, India).

RACE

GENDER AND SEXUALITY

U.S. Supreme Court rules that white workers may not be laid off to preserve the jobs of recently hired blacks or affirmative action hirings when company layoffs become necessary.

Rev. Jesse Jackson's campaign for U.S. presidency leads to a major increase in black voter turnout, particularly in the South.

First woman vice-presidential candidate of a major U.S. political party: Rep. Geraldine Ferraro (D., New York)

International March for Gay and Lesbian Freedom (New York)

The Guerrilla Girls, an activist art group committed to fighting sexism and racism in the New York art world, is founded.

1985

POLITICS

— U.S. Supreme Court bars
public school teachers
from parochial schools.

— Soviet and U.S. leaders
meet at summit.

— U.S. Congress enacts
budget-balancing bill.

RACE

GENDER AND SEXUALITY

Police and firefighters
demolish two city blocks
when they bomb the
headquarters of MOVE, a
radical African-American
urban rights group; 11
adults and children die
(Philadelphia).

The Buy Freedom
Campaign is created
to encourage and assist
African-American
enterprises.

Emily's List, political action
group to help elect women to
the U.S. Senate, is created.

Lesbians and gay men participate
in protests at the White House
as part of the April Actions for
Peace, Jobs, and Justice.

Gay and Lesbian Alliance
Against Defamation (GLAAD,
New York)

1986

POLITICS

— U.S. Immigration and
Naturalization Service establishes
amnesty program for illegal aliens.

— More than 350, 000 people
are homeless nationwide.

— Iran-Contra scandal is exposed.

— U.S. planes attack Libyan
"terrorist centers."

— World Court rules that U.S.
violated international law in
mining Nicaraguan waters.

— U.S. Supreme Court voids
automatic provisions of
balanced-budget law.

— U.S. Congress bars hiring
of illegal aliens.

RACE GENDER AND SEXUALITY

—— First official observance of —— U.S. Supreme Court rules in
 Martin Luther King Day *Bowers v. Hardwick* that private,
 consensual homosexual acts
—— Three African-American men are not protected by the U.S.
 seeking help in repairing their Constitution.
 car are attacked by a gang of
 white men hurling racial slurs —— U.S. Public Health Service
 and wielding bats. One of the adds AIDS to the list of
 black men is struck and killed "dangerous contagious
 by a car while fleeing the gang diseases" that prohibit
 (Howard Beach, New York). entry into the United States.

1987

POLITICS

—— Dow Jones industrial
average registers its single
biggest decline since 1914.

—— President Reagan accepts
"responsibility" for
Iran-Contra scandal.

—— U.S. Senate rejects
nomination of
conservative Robert H.
Bork to Supreme Court.

RACE GENDER AND SEXUALITY

The Center on Budget
and Policy Priorities reports
that one in three African
Americans is living below
the poverty level.

U.S. Merit Systems Protection
Board: sexual harassment cost
the government $267 million
in lost productivity and
turnover during a two-year
period.

GLAAD representatives
persuade the *New York Times*
to change its editorial policy
and use the word *gay* instead
of *homosexual*.

AIDS Coalition to Unleash
Power (ACT UP)

1988

POLITICS

— 270 people killed in terrorist
bombing of a Pan Am flight
(over Lockerbie, Scotland)

— U.S. Supreme Court upholds
public school officials' power
to censor student activities.

RACE

GENDER AND SEXUALITY

—— President Reagan authorizes
reparations payments and
apologizes to Japanese-
American survivors of World
War II internment camps.

—— George Bush is elected
president, continuing the
conservative civil rights
agenda of the Reagan
administration.

—— The U.S. Census Bureau
reports that almost six out of
10 African-American families
with one or more children
under the age of 18 are headed
by a single parent, nearly always
the mother.

—— The National Center for
Health Statistics confirms that
African-American people suffer
significantly higher death rates
than white people from certain
major illnesses.

—— The number of married
working mothers rises to
66 percent from 48 percent
in 1975.

—— Pope John Paul II issues
an apostolic letter listing
women's vocations as
"virginity and motherhood."

1989

POLITICS

—— *Exxon Valdez* oil tanker spills
11 million gallons of gasoline
into Prince William Sound,
killing more than half a million
birds and marine mammals and
devastating more than 1, 200
miles of coastline (Alaska).

—— Controversy surrounding
photographs by Robert
Mapplethorpe and Andres
Serrano begins debate on public
funding for the arts. National
Endowment for the Arts
becomes the subject of attack
by conservative politicians.

—— U.S. Supreme Court rules
that flag burning is protected
by First Amendment rights.

—— U.S. jury convicts Lt. Col.
Oliver L. North in
Iran-Contra affair.

—— Berlin Wall, after 28 years,
is open to the West.

—— U.S. troops invade Panama.

RACE GENDER AND SEXUALITY

First African-American
Chairman of the Joint Chiefs
of Staff: Gen. Colin Powell

Major civil rights organiza-
tions contend that a recent
flurry of U.S. Supreme
Court decisions has weak-
ened antidiscrimination laws
in hiring and promoting.

First black governor of
Virginia: L. Douglas Wilder

First black mayor of
New York: David Dinkins

Women and their supporters
stage a massive march on
Washington in support of
legal abortions, birth control,
and women's rights.

U.S. Supreme Court
upholds certain state-imposed
restrictions on abortion.

1990

POLITICS

—— South Africa frees Nelson Mandela.

—— Iraqi troops invade Kuwait, setting off Persian Gulf War.

—— Yugoslav Communists end 45-year monopoly of power.

RACE GENDER AND SEXUALITY

President Bush vetoes a civil rights bill that sought to reverse six recent U.S. Supreme Court decisions that civil rights organizations contend had weakened antidiscrimination laws in hiring and promoting.

The Federal Center for Disease Control reports that the homicide rate among African-American men aged 15 to 24 has risen 64 percent since 1984.

Two out of three women surveyed in a study of sexual harassment in the military say they have been sexually harassed.

One-third of families headed by women live below the poverty line.

Screen Actors Guild study finds that women constitute the smallest number of roles cast in SAG film and TV projects this year.

1991

POLITICS

—— U.S. forces declare victory in Persian Gulf War.

—— U.S. Supreme Court limits death row appeals.

—— South African Parliament appeals apartheid laws.

—— Warsaw Pact is dissolved.

RACE

GENDER AND SEXUALITY

— NAACP study concludes that African Americans are underrepresented in all aspects of the film and television industries.

— U.S. Census Bureau reports that 12 percent of African Americans 25 years or older have completed four years of college as compared to 22 percent of whites.

— Rodney King is beaten by police after being stopped while driving his car in Los Angeles. The subsequent release of an amateur video showing the beating stirs a national public outcry.

— Justice Thurgood Marshall, the only African-American to ever serve on the U.S. Supreme Court, retires.

— U.S. Senate approves the nomination of African-American jurist Clarence Thomas to serve as an Associate Justice of the U.S. Supreme Court after investigating allegations of sexual harassment leveled against him by law professor Anita Hill.

— New York Police Department survey concludes that 15 percent of reported bias crimes are motivated by anti-lesbian and anti-gay hate.

1992

POLITICS

—— U.S. and Russia proclaim
formal end to Cold War.

—— U.S. lifts trade sanctions
against China.

—— U.S. Senate ratifies second
Strategic Arms Limitation
Treaty.

—— U.S. forces end nearly a
century of military presence
in the Philippines.

—— U.N. approves U.S-led force
to guard food for Somalia.

RACE GENDER AND SEXUALITY

—— The acquittal of four white —— Women's Action Committee
police officers on all but one (WAC)
charge relating to the beat-
ing of black motorist Rodney —— Colorado voters pass a
King triggers the deadliest measure that bans local
and most costly race riot in antidiscrimination laws that
U.S. history (Los Angeles). specifically protect lesbians
 and gay men. (In landmark
—— William "Bill" Clinton ruling, measure is declared
is elected president with unconstitutional by U.S.
heavy support from African- Supreme Court in 1996.)
American, gay and lesbian,
and female voters.

—— U.S. Supreme Court strikes
down "hate crime" statute
in St. Paul designed to
ban cross-burning and
other expressions of racial
and religious intolerance
as a violation of freedom
of speech.

1993

POLITICS

——— Terrorist arrested in the
bombing of the World Trade
Center (New York).

——— U.S. Congress approves
North American Free Trade
Agreement (NAFTA).

——— New draft constitution
approved for Russia.

——— South Africa adopts
majority rule constitution.

RACE

GENDER AND SEXUALITY

—— President Bill Clinton
appoints several African
Americans to key cabinet
positions; his withdrawal of
Lani Guinier's nomination to
head the Justice Department's
civil rights division (over her
writings on racial quotas and
increasing minority voting)
evokes criticism from civil
rights leaders.

—— Racial segregation rises to
levels not seen since 1968:
while 66 percent of African-
American students attend
predominantly "minority"
schools, the trend also sug-
gests an increase in black
parents who choose to send
their children to Afro-centric
schools.

—— Second woman to be
appointed to U.S. Supreme
Court: Ruth Bader Ginsburg

—— President Clinton meets
with gay and lesbian leaders,
the first time such groups
have been openly welcomed
to the Oval Office.

—— Hundreds of thousands
of people participate in
a gay and lesbian rights
march (Washington, D.C.).

—— Colorado Supreme Court
nullifies state's anti-gay rights
measure. Gay and lesbian
rights activists end boycott
of state businesses.

1994

POLITICS

—— President Clinton ends
trade embargo on Vietnam.

—— Russia and NATO agree
on close military ties.

—— U.S. sends forces to
Persian Gulf.

—— Republicans win control
of U.S. House and Senate.

RACE

GENDER AND SEXUALITY

President Clinton tells
convention of black Baptists
that government alone
cannot halt decline in social
and moral standards; he
urges African-American
politicians to openly and
aggressively address issues
of family values and violence.

Entertainer Bill Cosby
and his wife, Camille,
donate historic landmark
building in Washington,
D.C., to help establish
a National Center for
African-American women.

U.S. State Department's
annual human rights report
documents widespread
day-to-day discrimination
and abuse of women in
193 countries.

U.S. Attorney General Janet
Reno orders federal civil
rights mediators from
Justice Department to take
up their first case involving
harassment of gay people.

Kraft General Foods
mandates that none of
its commercials be aired
during episode of TV
series "Roseanne" that
deals positively with
homosexuality.

1995

POLITICS

—— O.J. Simpson is found
not guilty of the murder
of his wife and her friend
(Los Angeles).

—— U.S. Congress curbs federal
mandates to states.

—— U.S. rescues Mexico's
economy.

—— Terrorist car bomb kills
hundreds in Federal building
(Oklahoma City).

RACE

GENDER AND SEXUALITY

Hundreds of thousands of
black men gather at Mall in
Washington, D.C., for historic
"Million Man March,"
organized by Nation of
Islam leader, Louis Farrakhan.

President Clinton, in a
major speech on racism
in the United States,
sternly challenges white
and black Americans to
take responsibility for
their racial attitudes.

Emotion-filled march com-
memorates 30th anniversary
of the Selma to Montgomery
civil rights march; former
governor George C. Wallace,
one of the South's staunchest
opponents of desegregation,
participates in a gesture of
contrition.

United Nations, Fourth
World Conference
on Women (Beijing)

U.S. Court of Appeals
upholds women's right
to enter Citadel military
academy (Charleston,
South Carolina).

LIST OF WORKS

ALL DIMENSIONS ARE GIVEN IN INCHES. LENGTH BY WIDTH BY HEIGHT.
UNLESS OTHERWISE INDICATED.

HANS HAACKE

1. *MOMA-Poll*, 1970
Installation
2 transparent acrylic ballot boxes
40 x 20 x 10 each
Collection of the artist

2. *The GoodWill Umbrella*, May 1976
6 silkscreen on acrylic panels
48 x 36 each
Collection of the artist

3. *Global Marketing*, 1986
4 wood, sheet metal, and silkscreen panels
48 x 48 each
Collection of the New Museum
of Contemporary Art, New York

MARY KELLY

1. *Post-Partum Document Prototype*, 1974
10 mixed media units
14 x 11 each
Collection of the artist

2. *Post-Partum Document Introduction*, 1973
4 mixed media units
14 x 11 each
Collection of the artist

3. *Potestas*, 1989
Brass and steel etching
100 x 114
Collection of the New Museum
of Contemporary Art, New York

ROBERT MORRIS

1. *Film of Dance Pieces*, 1962-65; 1993
 Director: Babette Mangold
 Dances reconstructed, 1993:
 Television studio, Hunter College, New York
 35mm color film
 Collection of the Guggenheim Museum,
 Soho, New York

2. *Untitled*, 1965; 1996
 Glass mirrors on wood cubes
 24 x 24 x 24 each
 Collection of the artist

3. " Separate Walkways: The Warden Above,
 The Inmates Below," from
 In the Realm of the Carceral, 1978
 Ink drawing on paper
 45 x 33 3/4
 Collection of the artist

4. " The Hot and Cold Pools of Persuasion,"
 from *In the Realm of the Carceral*, 1978
 Ink drawing on paper
 45 x 33 3/4
 Collection of the artist

5. " Arena of the Combatants,"
 from *In the Realm of the Carceral*, 1978
 Ink drawing on paper
 45 x 33 3/4
 Collectrion of the artist

6. " Cenotaph," from *Preludes (for A.B.)*, 1980
 Mixed media
 Size variable to site
 Collection of the artist

7. "Kelbasin," from *Disappearing Places*, 1990
 Lead panel relief
 40 x 30
 Collection of the artist

8. "Ossawa," from *Disappearing Places*, 1990
 Lead panel relief
 40 x 30
 Collection of the artist

9. "Belzer," from *Disappearing Places*, 1990
 Lead panel relief
 40 x 30
 Collection of the artist

ADRIAN PIPER

1. *Hypothesis Series*, (# 1, 4, 8, 9, 10, 19) 1969-70
 Photo chart collage
 Sizes variable
 Collection of the artist

2. *Black Box/White Box*, 1992
 Mixed media installation
 96 x 96 x 96 each
 Collection of the artist

YVONNE RAINER

1. Dance performance stills of Yvonne Rainer,
 1963-1972
 © Photographer: Peter Moore
 24 black & white photographs,
 with notations by Yvonne Rainer
 8 x 10 each
 Estate of Peter Moore

2. *Dance Notation Drawings*, 1962-72
 15 pencil on paper drawings
 Sizes variable
 Collection of the artist

3. Film loop with excerpts:
 Lives of Performers, 1972,
 16mm, black & white, sound
 Film About a Woman Who..., 1974,
 16mm, black & white, sound
 Kristina Talking Pictures, 1976,
 16mm, color and black & white, sound
 Journeys From Berlin/1971, 1980,
 16mm, color and black & white, sound
 The Man Who Envied Women, 1985,
 16mm, color and black & white, sound
 Privilege, 1990,
 16mm, color and black & white, sound
 MURDER and murder, 1996,
 16mm, color and black & white, sound

 All collection of the artist

A
SELECTED
BIBLIOGRAPHY

ANTIN, DAVID. "Art & Information, 1: Gray
Paint, Robert Morris." *Art News*, VOL.
63, NO. 8, April 1966, pp. 23-24, 56-58.

BANES, SALLY. *Democracy's Body: Judson Dance
Theater, 1962-64.* Ann Arbor: UMI
Research Press, 1983.

BARRY, JUDITH AND SANDY FLITTERMAN. "Textual
Strategies—The Politics of Art Making,"
Screen, VOL. 21, NO. 2, Summer 1980,
pp. 37-38.

BATTCOCK, GREGORY, ed. *Idea Art: A Critical
Anthology.* New York: E.P. Dutton,
1973.

_____ , ed. *Minimal Art: A Critical
Anthology.* New York: E.P. Dutton,
1968.

_____ , ed. *The New Art: A Critical
Anthology.* New York: E.P. Dutton,
1973.

BERGER, MAURICE. "The Critique of Pure
 Racism: An Interview with Adrian
 Piper." *Afterimage*, VOL. 18, NO. 3,
 October 1990, pp. 5-9.

——————. *How Art Becomes History:
 Essays on Art, Society, and Culture in
 Post-New Deal America.* New York:
 HarperCollins, 1992.

——————. *Labyrinths: Robert Morris,
 Minimalism, and the 1960s.* New
 York: Harper & Row, 1989.

BERGER, MAURICE AND JOHNNETTA COLE, eds.
 *Race and Representation:
 Art/Film/Video.* New York: Hunter
 College Art Gallery, 1987.

BERGER, MAURICE, BRIAN WALLIS, AND SIMON
 WATSON. *Constructing Masculinity.*
 New York and London: Routledge,
 1995.

BHABHA, HOMI. *The Location of Culture.*
 New York: Routledge, 1994.

Bois, Yve-Alain, Douglas Crimp, and Rosalind
Krauss. "A Conversation with Hans Haacke"
(interview). *October,* no. 30, Fall 1984, pp. 23-48.

Butler, Judith. *Bodies that Matter: On the
 Discursive Limits of "Sex."* New York
 and London: Routledge, 1993.

——————. *Gender Trouble: Feminism and
 the Subversion of Identity.* New York
 and London: Routledge, 1990.

Carlson, Marvin. *Performance: A Critical
 Introduction.* New York and London:
 Routledge, 1996.

Case, Sue-Ellen. *Feminism and Theater.*
 New York: Methuen, 1988.

Chave, Anna. "Minimalism and the Rhetoric
 of Power." *Arts Magazine,* January
 1990, pp. 44-63.

COOPER, HELEN, ed. *Eva Hesse: A Retrospective*.
New Haven: Yale University Art
Gallery, 1992.

DE DUVE, THIERRY, ed. *The Definitively
Unfinished Marcel Duchamp*.
Cambridge, Mass., and London:
M.I.T. Press, 1992

DE LAURETIS, TERESA. *Technologies of Gender*.
Bloomington and Indianapolis:
Indiana University Press, 1987.

DELEUZE, GILLES AND FELIX GUATTARI.
*Anti-Oedipus: Capitalism and
Schizophrenia*. Translated by Robert
Hurley, Mark Seem, and Helen
Lane. Minneapolis: University
of Minnesota Press, 1983.

FERGUSON, RUSSELL, et al., eds. *Out There:
Marginalization and Contemporary
Cultures*. Cambridge, Mass., and
London: M.I.T. Press, 1990.

FOSTER, HAL. "The Crux of Minimalism."
 In *Individuals: A Selected History
 of Contemporary Art, 1945-1986*.
 New York: Abbeville Press, 1986,
 pp. 31-74.

FOUCAULT, MICHEL. *The Archaeology of
 Knowledge*. Translated by A. M.
 Sheridan Smith. New York:
 Pantheon, 1972.

——— . *Discipline and Punish: The Birth
 of the Prison*. Translated by Alan
 Sheridan. New York: Vintage Books,
 1979.

——— . *The History of Sexuality. Volume
 II: The Care of the Self*. Translated by
 Robert Hurley. New York: Vintage
 Books, 1988.

FRIED, MICHAEL. "Art and Objecthood."
 In Gregory Battcock, ed. *Minimal
 Art: A Critical Anthology*. New York:
 E.P. Dutton, 1968, pp. 116-47.

GATES, HENRY LOUIS, JR. *The Signifying Monkey:*
 A Theory of African American Literary
 Criticism. New York: Oxford University
 Press, 1988.

GOLDEN, THELMA, et al. *Black Male: Representations*
 of Masculinity in Contemporary American
 Art. New York: Whitney Museum of
 American Art, and New York: Harry
 N. Abrams, 1995.

GREER, GERMAINE. *The Female Eunuch.*
 New York: McGraw-Hill, 1971.

HAACKE, HANS. "Hans Haacke: Systems
 Aesthetics" (Interview). In Jeanne
 Siegel. *Artwords: Discourse on the 60s*
 and 70s. Ann Arbor: UMI Research
 Press, 1985, pp. 211-20.

hooks, bell. *Yearning: Race, Gender,*
 and Cultural Politics.
 Boston: South End Press, 1990.

JAMESON, FREDRIC. *Marxism and Form.* Princeton:
 Princeton University Press, 1972.

JONES, AMELIA, ed. *Sexual Politics: Judy Chicago's
 "Dinner Party" in Feminist Art History.*
 Berkeley and Los Angeles: University of
 California Press, 1996.

JUDD, DONALD. *Donald Judd: Complete Writings,
 1959-1975.* Halifax: Press of the Nova
 Scotia College of Art, 1975.

KAUFFMAN, LINDA, ed. *Gender and Theory:
 Dialogues on Feminist Criticism.*
 New York: Basil Blackwell, 1989.

KELLY, MARY. *Gloria Patri.* Middletown, Conn.:
 Ezra and Cecile Zilkha Gallery,
 Wesleyan University, 1992.

——————. *Imaging Desire.* Cambridge, Mass.,
 and London: M.I.T. Press, 1996.

——————. *Post-Partum Document*. London:
Routledge & Kegan Paul, 1983.

——————. "Re-viewing Modernist
Criticism." *Screen*, VOL. 22, NO. 23,
1981, pp. 41-62. Reprinted in Kelly,
Imagining Desire. Cambridge, Mass.,
and London: M.I.T. Press, 1996.,
p. 93

KRAUSS, ROSALIND. *The Originality of the
Avant-Garde and Other Modernist
Myths*. Cambridge, Mass., and
London: M.I.T. Press, 1985.

——————. *Passages in Modern Sculpture*.
New York: Viking, 1977.

——————. "Sense and Sensibility:
Reflections on Post '60s Sculpture."
Artforum, November 1973,
pp. 43-53.

KRISTEVA, JULIA. *Feminist Theory: A Critique of
Ideology.* Translated by Alice Jardine
and Henry Blake. Chicago:
University of Chicago Press, 1982.

KUENZLI, RUDOLPH, ed. *Marcel Duchamp: Artist
of the Century,* Cambridge, Mass.,
and London: MIT Press, 1989.

LACAN, JACQUES. *Ecrits.* New York: Tavistock,
1977.

_____. *Feminine Sexuality.* Edited by
Juliet Mitchell and Jacqueline Rose.
New York: Norton, 1982.

LAING, R.D. *The Divided Self.* London:
Penguin, 1965.

_____. *The Politics of Experience.*
New York: Ballantine, 1967.

LEBEL, ROBERT. *Marcel Duchamp.* New York:
Grove Press, 1959.

LINKER, KATE, et al. *Difference: On Representation and Sexuality.* New York: New Museum of Contemporary Art, 1984.

LIPPARD, LUCY. *From the Center: Essays on Women's Art.* New York: E.P. Dutton, 1976.

_____ . *Mixed Blessings: New Art in a Multicultural America.* New York: Pantheon, 1990.

_____ . *The Pink Swan: Selected Feminist Essays on Art.* New York: New Press, 1995.

LORDE, AUDRE. "Age, Race, Class, and Sex: Women Redefining Difference." In Russell Ferguson, et al., eds. *Out There: Marginalization and Contemporary Culture.* Cambridge, Mass., and London: M.I.T. Press, 1990, pp. 281-87.

MASTAI, JUDITH, ed. *Social Process/Collaborative
 Action: Mary Kelly, 1970-75*. Vancouver,
 British Columbia: Charles H. Scott
 Gallery, Emily Carr Institute of Art
 and Design, 1997.

MELVILLE, STEPHEN. "Notes on the Reemergence
 of Allegory, the Forgetting of
 Modernism, the Necessity of Rhetoric,
 and the Conditions of Publicity in Art
 and Criticism." *October*, NO. 19, Winter
 1981, pp. 55-92.

MERCER, KOBENA. "Welcome to the Jungle:
 Identity and Diversity in
 Postmodern Politics." In Jonathan
 Rutherford, ed. *Identity: Community,
 Culture, Difference*. London:
 Lawrence & Wishart, 1990,
 pp. 43-71.

MICHELSON, ANNETTE. "Robert Morris:
 An Aesthetics of Transgression."
 In *Robert Morris*. Washington, D.C.:
 Corcoran Gallery of Art, 1969.

MITCHELL, JULIET. *Psychoanalysis and Feminism.*
New York: Pantheon, 1974.

MOI, TORIL. *Sexual/Textual Politics: Feminist
Literary Theory.* New York: Methuen,
1985.

MORRIS, ROBERT. "Aligned with Nazca."
Artforum, October 1975,
pp. 33-35.

―――――. *Continuous Project Altered Daily:
The Writings of Robert Morris.*
Cambridge, Mass., and London:
M.I.T. Press, 1994.

―――――. "Notes on Dance." *Tulane
Drama Review*, VOL. 6, Winter 1965,
pp. 180-83.

―――――. *Robert Morris: Mirror Works.*
New York: Leo Castelli Gallery,
1979.

MULVEY, LAURA. "'Post-Partum Document'
by Mary Kelly." In Roszika Parker
and Griselda Pollock, eds. *Framing
Feminism: Art and the Women's
Movement, 1970-1985*. London
and New York: Pandora, 1987.

————— . "Visual Pleasure and Narrative
Cinema." In Constance Penley, ed.
Feminism and Film Theory. New York:
Routledge, 1988.

O'DELL, KATHY. *Contract with the Skin:
Masochism, Performance Art, and the
1970s*. Minneapolis: University of
Minnesota Press, 1998.

————— . *Kate Millett, Sculptor: The First
38 Years*. Baltimore: Fine Arts
Gallery, University of Maryland,
Baltimore County, 1997.

OWENS, CRAIG. *Beyond Recognition:
Representation, Power, and Culture*.
Edited by Scott Bryson, Barbara
Kruger, Lynne Tillman, and Jane
Weinstock. Berkeley and Los
Angeles: University of California
Press, 1993.

PARKER, ANDREW AND EVE KOSOFSKY SEDGWICK,
eds. *Performativity and Performance.*
New York and London: Routledge,
1995.

PINCUS-WITTEN, ROBERT. *Post Minimalism into
Maximalism: American Art 1966-1986.*
Ann Arbor: UMI Rresearch Press,
1987.

PIPER, ADRIAN. *Decide Who You Are.* New York,
The Paula Cooper Gallery, 1992.

_____. *Out of Order, Out of Sight.*
*Volume I: Selected Writings in Meta-Art,
1968-1992. Volume II: Selected Writings
in Art Criticism.* Cambridge, Mass. and
London: M.I.T. Press,1996.

_____. "Passing for White, Passing
for Black." *Transition,* NO. 58, 1992,
pp. 4-32.

_____. "Xenophobia and the Indexical
Present." In Mark O'Brien and Craig
Little, eds. *Reimaging America: The Arts
of Social Change.* Philadelphia: New
Society Publishers, 1990, pp. 280-90.

POLLOCK, GRISELDA. "Histories." In Judith Mastai, ed., *Social Process/Collaborative Action: Mary Kelly, 1970-75*. Vancouver, British Columbia: Charles H. Scott Gallery, Emily Carr Institute of Art and Design, 1997, pp.33-56.

RAINER, YVONNE. *The Films of Yvonne Rainer.* Bloomington and Indianapolis: Indiana University Press, 1989.

—————. "The Performer as a Persona." *Avalanche*, Summer 1972, pp. 50-53.

—————. "A Quasi Survey of Some 'Minimalist' Tendencies in the Quantitatively Minimal Dance Activity Midst the Plethora, or an Analysis of Trio A." In Gregory Battcock, ed. *Minimal Art: A Critical Anthology*, New York: E.P. Dutton, 1968, pp. 263-73.

—————. *Work 1961-73*. Halifax: Nova Scotia College of Art and Design, and New York: New York University, 1974.

ROGERS, SARAH. *Will/Power*. Columbus:
 Wexner Center for the Arts, 1992.

ROSE, BARBARA. "ABC Art." In Gregory Battcock,
 ed. *Minimal Art: A Critical Anthology*.
 New York: E. P. Dutton, 1968,
 pp. 275-97.

ROTH, MOIRA. "Autobiography, Theater,
 Mysticism, and Politics: Women's
 Performance Art in Southern California."
 In Carl Loeffler and Darlene Tong, eds.
 Performance Anthology. San Francisco:
 Last Gasp Press, 1989, pp. 460-70.

RUTHERFORD, JONATHAN, ed. *Identity:
 Community, Culture, Difference*.
 London: Lawrence & Wishart, 1990.

SAID, EDWARD. "An Ideology of Difference."
 Critical Inquiry, VOL. 12, NO.1,
 Autumn 1985, pp. 38-58.

SANDBACK, AMY BAKER, ed. *Looking Critically:
 21 Years of Artforum Magazine*.
 Ann Arbor: UMI Research Press,
 1984, pp. 143-48.

SAYRES, SONIA, et al., eds. *The 60's Without Apology*. Minneapolis: University of Minnesota Press, 1984.

SEDGWICK, EVE KOSOFSKY. *Epistemology of the Closet*. Berkeley: University of California Press, 1990.

SNITOW, ANN, et al., eds. *Powers of Desire: The Politics of Sexuality*. New York: Monthly Review Press, 1983.

SOLOMON R. GUGGENHEIM MUSEUM. *Robert Morris: The Mind/Body Problem*. New York, 1994.

SOLOMON-GODEAU, ABIGAIL AND CONSTANCE LEWALLEN. *Mistaken Identities*. Santa Barbara: University Art Museum, University of California, Santa Barbara, 1992.

SPIVAK, GAYATRI CHAKRAVORTY. *In Other Worlds: Essays in Cultural Politics*. New York and London: Routledge, 1987.

STORR, ROBERT. *Dislocations*. New York: Museum of Modern Art, 1992.

THEWELEIT, KLAUS. *Male Fantasies*. Two volumes. Minneapolis: University of Minnesota Press, 1987.

TUCKER, MARCIA, et al. *Bad Girls.* New York:
New Museum of Contemporary Art
and Cambridge, Mass., and London:
M.I.T. Press, 1995.

WALLACE, MICHELLE. *Black Macho and the
Myth of the Superwoman.*
New York: Dial Press, 1979.

WALLIS, BRIAN, ed. *Hans Haacke: Unfinished
Business.* New York: New Museum of
Contemporary Art, and Cambridge,
Mass.: M.I.T. Press, 1984.

WEST, CORNEL. *Keeping Faith: Philosophy
and Race in America.* New York
and London: Routledge, 1993.

_____."The Dilemma of the Black
Intellectual." *Cultural Critique,*
VOL. I, NO. I, Fall 1985.

WITTIG, MONIQUE. *The Lesbian Body.*
New York: William Morrow, 1975.

ZELEVANSKY, LYNN. *Sense and Sensibility:
Women Artists and Minimalism
in the 1990s.* New York: Museum
of Modern Art, 1994.

ISSUES

IN

CULTURAL

THEORY

1

MINIMAL POLITICS

PERFORMATIVITY

AND

MINIMALISM

IN

RECENT

AMERICAN

ART

SERIES EDITOR: MAURICE BERGER
MANAGING EDITOR: ANTONIA LaMOTTE GARDNER
COVER, BOOK DESIGN & TYPOGRAPHY: FRANC NUNOO-QUARCOO

FINE ARTS GALLERY
EXECUTIVE DIRECTOR: DAVID YAGER
DIRECTOR OF PROGRAMS: SYMMES GARDNER
ADJUNCT CURATOR: MAURICE BERGER
PROJECTS COORDINATOR: MONIKA GRAVES

TYPESET IN TRAJAN, JANSON ROMAN, ITALIC AND SMALL CAPS
PRINTED AND BOUND BY H&N PRINTING & GRAPHICS
ON 80LB TEXT MOHAWK VELLUM AND CAROLINA CIS COVER